Great Modern Masters

F. LEGER

Léger

General Editor: José María Faerna

Translated from the Spanish by Alberto Curotto

CAMEO/ABRAMS

HARRY N. ABRAMS, INC., PUBLISHERS

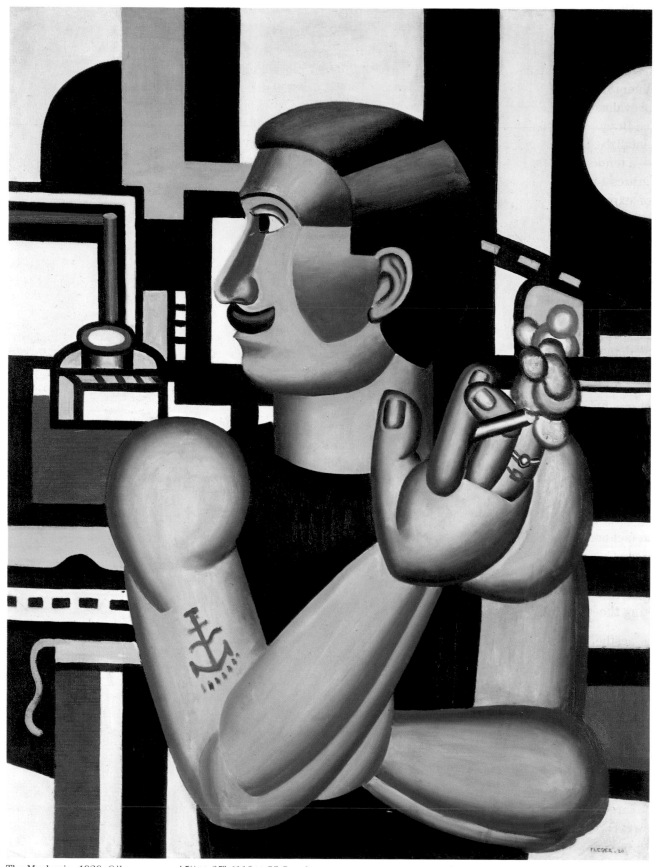

The Mechanic. *1920. Oil on canvas, 45½ × 35″ (116 × 88.8 cm).*
The National Gallery of Canada, Ottawa

Léger, the Naïve Cubist

Critics of the art of the first half of our century have often been too rigid in their thinking. This is seen nowhere more clearly than in the shifting critical evaluation of Fernand Léger, along with such other artists as Georges Braque and Giorgio de Chirico. An excessive tendency to compartmentalize, that is, to focus on the more clearly defined artistic movements—a tendency fostered by the rhetoric of the avant-garde itself—led some critics to exclude from the artistic pantheon, or even ignore, any form of expression that could not be so easily classified. The opinion therefore became widespread that after 1930, following the close of Léger's Cubist period, his subsequent work lost virtually all serious interest.

A Popular Artist

Nonetheless, it can legitimately be claimed that the best-known works by Léger, those most firmly fixed in the popular imagination, are his brightly colored depictions of cyclists with unworried faces, his workers who somehow partake of the metallic nature of their tools, and his affirmations of faith in the essential goodness of modern civilization—in other words, the pictures he painted after 1930. The reasons for this seeming paradox are many and varied. Most of all, however, they have to do with the unusual nature of Léger's gifts as an artist. The success of his Cubist period is to be found in his great originality, both in building upon the lessons of Paul Cézanne's art—which he did in a surprisingly literal manner—and in his search for an alternative to the orthodox Cubism of Picasso and Braque. The key to understanding Léger's work is to see that his special achievement in fact arose from precisely the way that he did not, after all, fit easily into the Cubist category.

Woman Sewing, c. 1910. Arguably the earliest example of Léger's personal interpretation of Cézanne and the prelude to the so-called "Tubist" period.

Depicting the Machine

Léger's aesthetic preoccupations actually situate him somewhere between the Cubists and the Italian Futurists. Like the Cubists, he absolutely refused to attribute any sentimental or literary value to the work of art, which he held to be independent of nature and, therefore, ruled by its own set of laws. Likewise derived from Cubism was his stringent investigation of possible new ways to represent space in a picture, ways that bypassed the system of perspective inherited from the Renaissance. Yet with the Futurists, Léger shared a devotion to the new mechanical inventions that were leading some to call the modern era the Machine Age and were fostering a largely technological view of civilization. Léger's principal interest, however, remained the realm of line, color, and form; the aggressive impulse of the Futurists to change the world around them was foreign to him. Léger's fascination with industrial objects was instead a kind of aesthetic pantheism—an eagerness to discover beauty everywhere, including, as he said, "in the arrangement of a set of pots and pans hanging on a white kitchen wall." This conviction inspired his entire post-Cubist work, which is to say, almost thirty years of artistic production.

Léger turned the figure into a kind of grand industrial machinery, and this has been seen by some as lessening the importance of the personal

Composition No. 1, 1927. In the late 1920s, Léger's work was marked by the influence of the Purist movement, led by Le Corbusier.

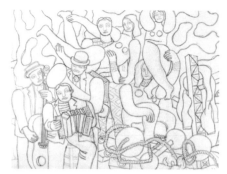

Acrobats and Musicians, *1948. A meticulous artist, Léger always made a number of preparatory sketches for his larger compositions.*

The Constructors, *1951. In his mature works, Léger relaxed the tectonic rigor of his early period in order to achieve more organic compositions.*

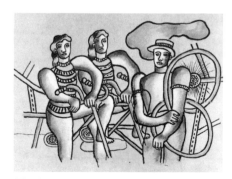

The Cyclists, *1950. Léger was always attracted to the world of the circus. Especially in his works after 1945, he depicted many acrobats, cyclists, and tumblers.*

element, reducing the human body to a mere mechanical object. There has been plentiful criticism along these lines, and some of it has even branded his work "dehumanizing." Such accusations are based on a gross misconception of what the artist was about. The spirit of these works is that of an individual profoundly confident in the idea of progress, and convinced of the possibility of putting nature more fully at the service of human needs, precisely through technical advances. So powerful was Léger's optimism about the future of humankind that his work lacks much of the overt criticism of modern life that often characterizes the avant-garde, and as a result it has seemed conformist or complaisant to some commentators.

The Function of Art

Léger's optimism did not include any firm sense that a work of art could operate directly as an agent of change, or act in a specific, concrete way to bring about a better world. Like his contemporaries, Léger was indeed concerned with the social consequences of artistic activity, but he did not share the Constructivists' or the Surrealists' faith in the revolutionary character, or in the immediacy, of its effects. Having learned through experience how difficult it can be for most people to come to understand contemporary artworks, Léger entertained only modest social ambitions for art. For him, its aim was limited to enhancing the environment in which people live, countering its more unpleasant aspects. This guiding purpose can be seen in the high value he placed on visual clarity, on making art accessible, and in his rejection of elitism. It also led him to his notion of a large-scale monumental art, adapted to the expansive spaces offered by modern architecture and available to large numbers of people. In these pursuits, Léger was a genuine pioneer. For example, his ideas about public mural painting and the need for precise outlines, as well as his freedom of color, would greatly influence the world of advertising, and would ultimately be claimed as their own by the Pop artists of the 1960s. Many other links leading from his work to Pop art can be seen. The frequent claim by sixties artists that everyday objects are endowed with unique aesthetic qualities—though this view was tinged with some irony, derived from Dadaism—points to one of Léger's most conspicuous contributions. It is even possible to find an antecedent in his art for the kind of performance later known as the "happening," when, for the 1937 World's Fair, he proposed that every wall in Paris be whitewashed, by the three hundred thousand unemployed in the city at the time. As might be expected, his proposal was turned down, but he believed that it would have made a phenomenal "event."

A Modern Classicism

Time has confirmed the aspirations of an artist who so often expressed the desire to be the pioneer of a future era. Léger had the rare ability to represent the defining aspects of an age that was still in the process of emerging. He helped perfect the characteristic pictorial forms of the industrial era, as the Romanesque sculptor had fixed the image of feudal society. And certainly, from the vantage point of our electronic, post-industrial era, we cannot fail to recognize the now classic style that he gave to the tools of the modern age—the streamlined, brightly colored forms of Léger's mechanical Arcadia.

Fernand Léger/1881–1955

Jules-Henri-Fernand Léger was born in Argentan, Normandy, in 1881. Despite his frequent travels and his success, Léger, the son of a cattle breeder, always retained the unassuming air of a vigorous Norman peasant. When he was sixteen, his precocious gifts prompted his family to send him to Caen to serve an apprenticeship with an architect. With this background, he was able to earn a living as an architectural draftsman when he arrived in Paris in 1900. Three years later, after failing to gain admission at the École des Beaux-Arts, he enrolled at the École des Arts Décoratifs while at the same time attending the celebrated Académie Julian.

The Influence of Cézanne

Within a few years, Léger gained access to the world of the Parisian avant-garde. In 1908, he moved into a building in Montparnasse known as La Ruche (The Beehive), which, living up to its name, housed a great deal of artistic activity. Here he met, among others, Robert Delaunay, whose Cubist experience he would later share; the poet Blaise Cendrars, with whom he formed a very close friendship; as well as Alexander Archipenko, Jacques Lipchitz, and Marc Chagall. After some early paintings executed in an Impressionist-related style, the encounter with Paul Cézanne's work, especially at the memorial retrospective exhibition presented in 1907, proved crucial for Léger's development. In 1909–10, he painted *Nudes in the Forest* (plate 3), which marked a great personal advance, displaying what he had learned from Cézanne's precept to seek in nature the forms of "the cone, the cylinder, the sphere."

Self-Portrait, *1930. Tall, broad-shouldered, and robust, Léger conveyed a sense of strength and vitality consistent with his work.*

Cubism

In the years 1911–13, his contact with the latest works of Pablo Picasso and Georges Braque gave rise to a number of paintings of Cubist derivation. Nonetheless, like his friend Delaunay, Léger loved open urban spaces and therefore avoided the hothouse atmosphere—typified by Picasso's and Braque's preoccupation with still life—that had helped define Cubism proper. Instead, he painted cityscapes, with the play of light on dappled roofs and smoke rising from chimneys. And color, which Analytical Cubism in particular had suppressed, appeared profusely in Léger's work, revealing an already marked taste for strong contrast.

Until 1912, driven by the logic of Cubist "decomposition"—that is, its way of breaking down an object into its constituent elements—his paintings drew nearer to the border of true abstraction, seeking absolute independence from the objective world. The works of this time led the poet Guillaume Apollinarie to associate Léger with the group he dubbed the Orphic painters, whose style was related to Cubism but distinguished from it by a more lyrical, sensuous use of color. In 1913, Léger began to focus more intently on contrasts between shapes and produced a series of works devoted to the geometry of cones and cylinders, now presented in a truly abstract manner, to the point where outline and color appeared to be dissociated from each other.

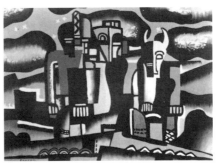

Scenic design for La Création du monde, *1924. Léger collaborated on this ballet by Blaise Cendrars, designing the costumes and sets.*

The experience of serving in the French military during World War I was a turning point in Léger's life. Having enlisted in the army engineers, he fell victim to a poison-gas attack at the Verdun front and was hospitalized. But

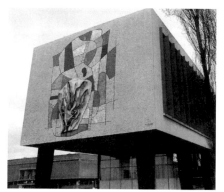

Mosaic for the Gaz de France building, Alfortville, 1955. Léger advocated the integration of painting and architecture.

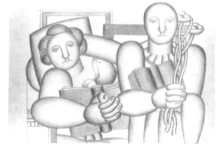

Study for The Readers, *1923. Many of Léger's preliminary studies, for the most part in pencil, are more than mere sketches, and amount to works of art in their own right.*

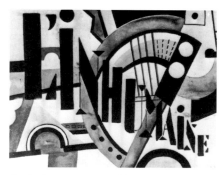

Study for a poster for L'Inhumaine, *c. 1923. This film, for which Léger also designed the sets, had a musical score by Darius Milhaud.*

unlike most of his artist contemporaries, who produced bitter visions of the conflict, Léger recalled that, for him, this period yielded some extremely valuable lessons, not only teaching him about the need to preserve humane values but also molding his respect for the aesthetic properties of modern machines. These qualities would inform his first postwar paintings, with their constant effort to present mechanical objects in a positive way—as objects of visual contemplation.

A New Classicism

Beginning in 1920, the human figure reappeared in Léger's work, with a number of compositions in which it is equated with industrial elements. At the same time, his strong interest in the special character of modern life, together with his wish to expand the narrow limits of what was available to art, led to work for film and dance. In 1922 and 1923, he designed the sets for two ballets, *Skating Rink*, with music by Arthur Honneger, and *La Création du monde*, with a scenario by Blaise Cendrars and music by Darius Milhaud. In 1924, he directed and produced what is generally considered one of the first scriptless films, *Ballet mécanique*.

There followed a period, from 1924 to 1927, during which his output reflected the principles of Purism, expounded by the architect and painter Charles-Édouard Jeanneret, known as Le Corbusier, whom he had met in 1920. Then Léger's work entered a new phase, in which the human form acquired a centrality that it would maintain for the rest of his career. Although still sharing the space of the picture with ordinary, everyday objects, the figure now gained a truly heroic monumentality, while shedding that vestigial sense of being an inanimate robot that it had had in the previous periods of the artist's output.

In the following decade, Léger realized his ambition to create a new kind of classicism, suited to modern times. Despite the political unrest that France was enduring, Léger's paintings from the late thirties project a modest, straightforward optimism and a devotion to clarity, part of his intention to create a more popular kind of modern painting.

World War II forced him into exile. In September 1940, Léger left France and settled in New York. The visual character of the city—which he later described as a "colossal spectacle"—immediately possessed him. The variegated effects of light in the metropolis inspired fresh visual discoveries in the work of his American period.

Last Years

The war over, in 1945 Léger returned to France and began his last great phase of creative activity. His commissions included set designs for the theater and for the ballet *Le Pas d'acier*, to music by Sergei Prokofiev, in 1948; as well as stained glass windows, such as those for the Church of Sacré-Cœur, Audincourt, in 1950; and he executed a monumental mural for the United Nations building in New York in 1952. His social concerns—in 1945 he joined the Communist Party—are demonstrated by paintings that, in a disarmingly straightforward manner, celebrated the leisure and labor of working people. The heroic figure paintings from his final decade rival in power the works that had first secured his international reputation in the 1920s. At the height of his fame, Léger was awarded the Grand Prize at the São Paulo Bienal exhibition in 1955, the year of his death.

Plates

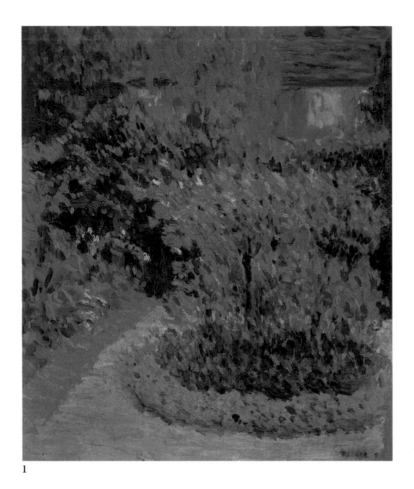

1

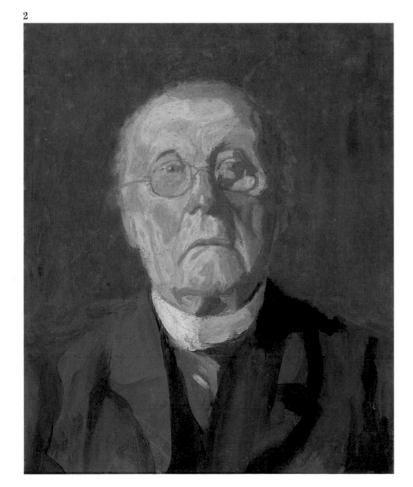

2

Toward Cubism

Léger painted his first works in a manner derived from late Impressionism, which by then had become a widely accepted style. He admired the courage with which the original Impressionists had stripped the work of art of all symbolic and literary content, of anything that did not further a concern with color and with light. Soon, though, he abandoned his Impressionist mode, persuaded that the modern world as he experienced it had little in common with the sun-drenched natural paradise so often depicted by those painters. This change was in large part brought about by Léger's visit to a 1907 memorial exhibition of the art of Paul Cézanne, one the greatest geniuses associated with Post-Impressionism, who had died the year before. As Léger himself acknowledged, it was from Cézanne's work that he learned to love abstract shapes as entities in themselves, and to concentrate on creating a composition that would be both precise and utterly devoid of sentimentality. Léger would apply with thoroughgoing radicality Cézanne's directive "to find in nature the cone, the cylinder, the sphere." This is most clearly evident in a painting such as *Nudes in the Forest* (plate 3), which earned for him the epithet of "Tubist" painter—because of the way its tubular forms replace the "little cubes" (as Henri Matisse had called them) of Cubism. In the works from this period, Léger's preoccupation with shape and volume gave rise to what are essentially sculptural compositions, with little interest in color.

1, 2 My Mother's Garden, *1905;* Portrait of the Artist's Uncle, *1905. Of all the works painted before 1907, only these two survive; the artist destroyed the rest. They are primarily of documentary interest. In these two conventional works, Léger rigorously applied Impressionist techniques, although his use of color approached Fauvism.*

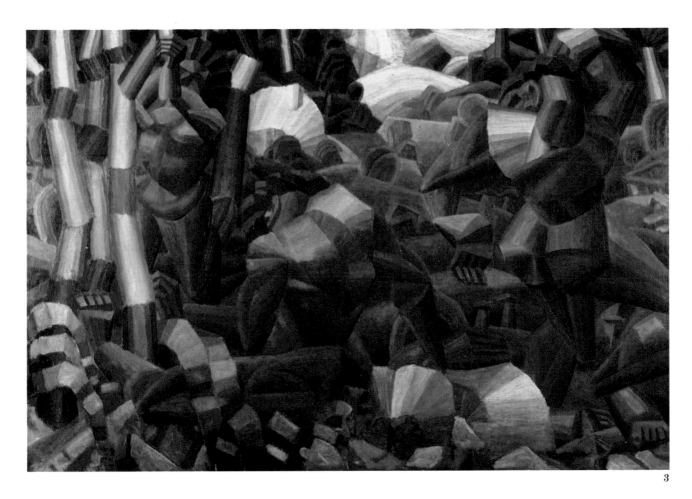

3 Nudes in the Forest,
*1909–10. A crucial work in
Léger's artistic career and
one about which Apollinaire,
the great apologist of Cubism,
said: "The woodcutters bore
on their bodies the sign of the
blows that their axes were
dealing to the trees, and the
overall color partook of the
deep greenish light filtering
down through the foliage."*

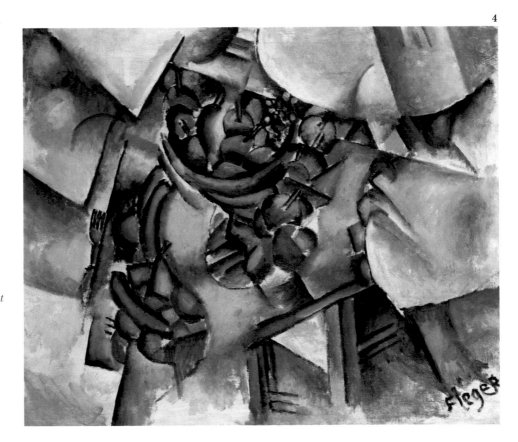

4 Fruit Dish on a Table,
*1909. Léger's aim to represent
space without regard for the
precepts of Renaissance
perspective, as well as his
choice of an extremely
subdued palette, shows his
closeness to the Analytical
Cubism that Picasso and
Braque were practicing at
the time.*

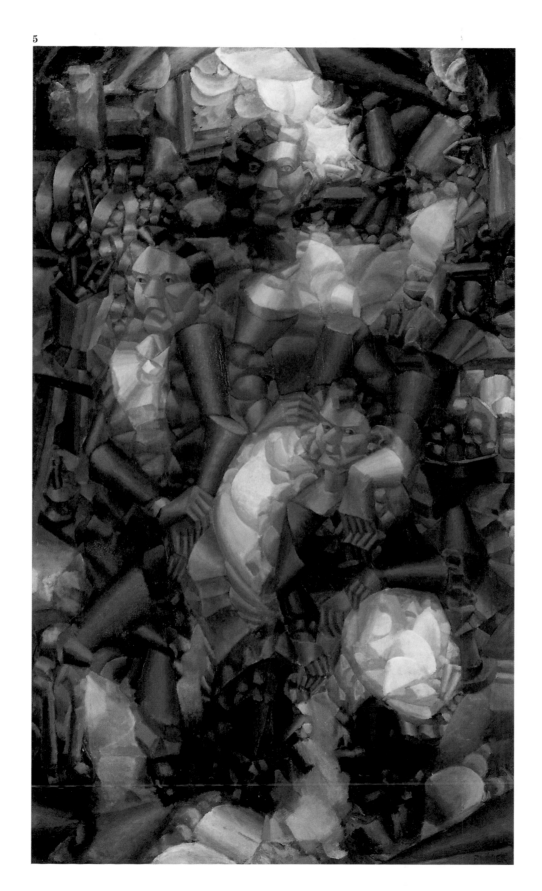

5 Three Figures (Study for Three Portraits), *1910–11. In this characteristic work from the "Tubist" period, Léger built his entire painting, both figures and setting, out of elementary shapes, essentially cylinders and cones. Apollinaire said that this composition looked like a mass of automobile tires.*

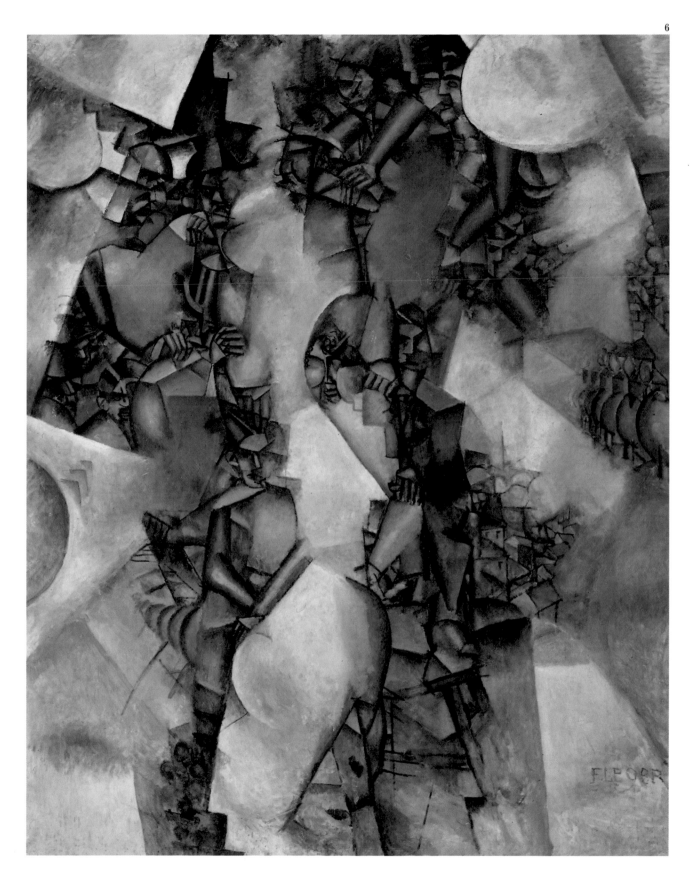

6 The Wedding, *1910–11. With scarcely any vestigial trace of perspective, in this picture the volumetric figures are broken up and stacked in two columns between open, lighter areas of flat plane. Along with the figures, some landscape features are visible, but the subject alluded to in the title is difficult to discern.*

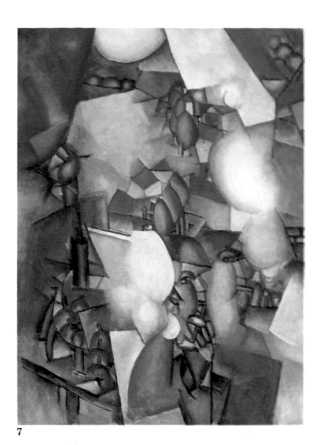

7

7, 8 The Smokers, *1911;* Railroad Crossing, *1912.*
*These two paintings demonstrate Léger's notion of
the laws of contrast: subdued hues are set against
areas of more intense color, and sharp-edged
geometric shapes against clouds of smoke. Each
scene is framed in a Cubist space.*

8

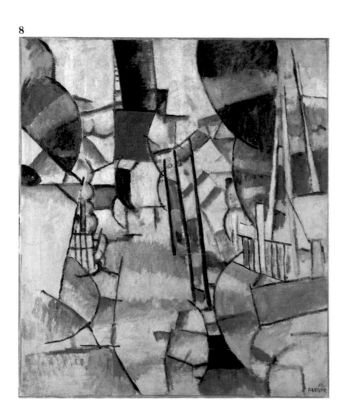

Toward Abstraction

Léger's Cubism differs substantially from the contemporaneous works of Pablo Picasso and Georges Braque, who were pursuing an art of private visual contemplation, conducted away from the hustle and bustle of the outside world. Léger apparently shared his friend Robert Delaunay's opinion that the highly refined early Cubist works of Picasso and Braque seemed to have been "painted with spider webs." And like Delaunay, he drew much of his inspiration from the exhilarating clamor, from the sheer energy, of modern city life. To capture this dynamism, Léger did not, however, avail himself of the Futurists' technique of superimposing successive images to give a sense of motion. He chose instead to apply the laws of visual contrast, which he considered a universal principle in the art of all times: he set off straight lines against curves, smooth, flat surfaces against rounded shapes, and pure local colors against shades of gray. Later, around 1913, his desire to focus on the dynamics of shape led him to move beyond even these complex compositions in favor of what has been called an "abstract Cézannism," pursuing a process of rigorous geometrization. Now, the interaction of elementary forms played itself out in a series of almost completely abstract paintings. Such titles as *Contrast of Forms* (see plate 13) clearly demonstrated the painter's intentions.

9 Woman in Blue, *1912. The logic of Cubism led Léger to break up
the representational elements in his paintings into more abstracted
forms. Over the image of a woman sitting with entwined fingers in
an armchair, the painter lays a series of colored planes, abstracting
her blue dress into a number of independent geometric shapes that
float before the figure.*

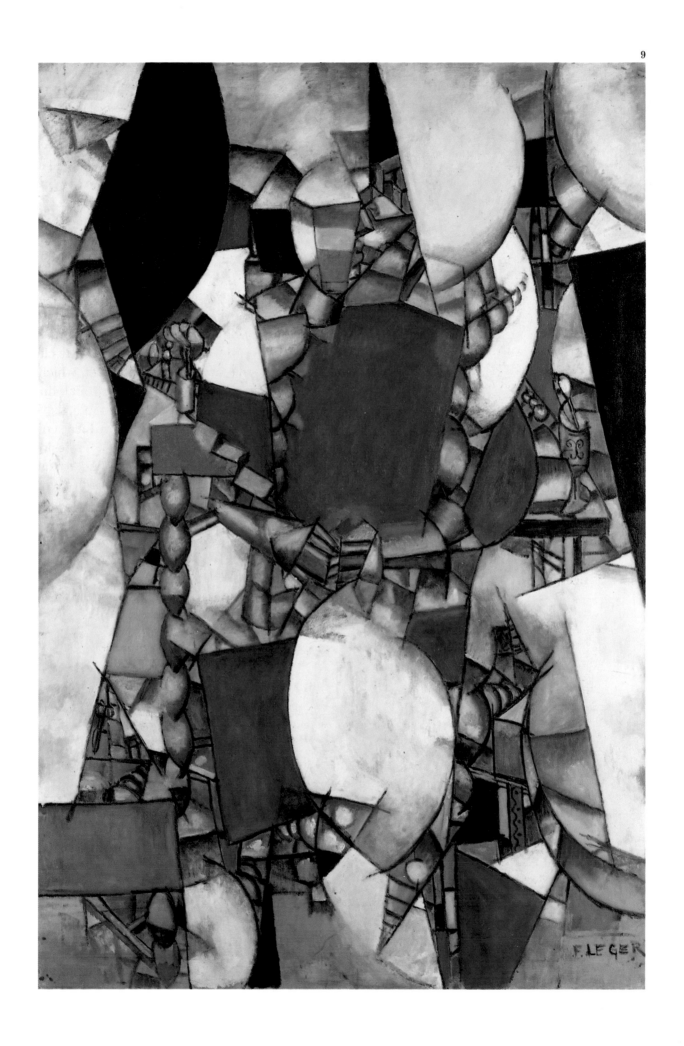

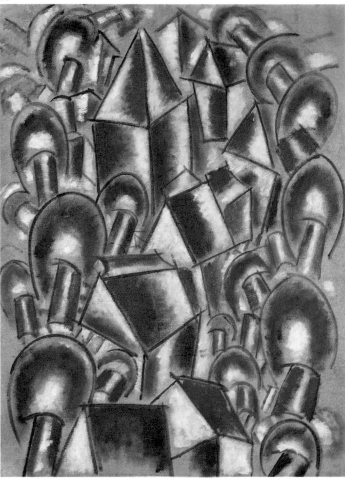

10 Houses Under the Trees (Landscape No. 3), *1914.*
Léger abandons the use of arbitrary color planes to
focus on a few shapes that, again, he molds out of
elementary volumes.

11, 12 The Staircase, *1913;* The Staircase, *1914. It is*
difficult not to be reminded here of Marcel Duchamp's
Nude Descending a Staircase, *painted in 1912. Léger,*
however, does not depict a single nude passing
through the successive stages of descent, but rather
a number of individuals so depersonalized that their
bodies merge with the angular configuration of the
stairs.

11

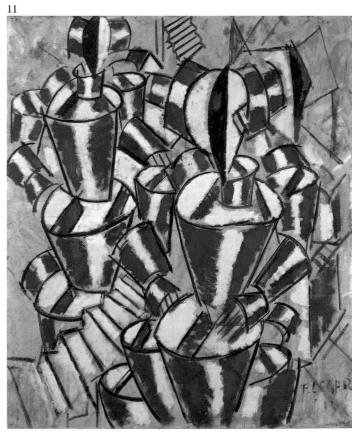

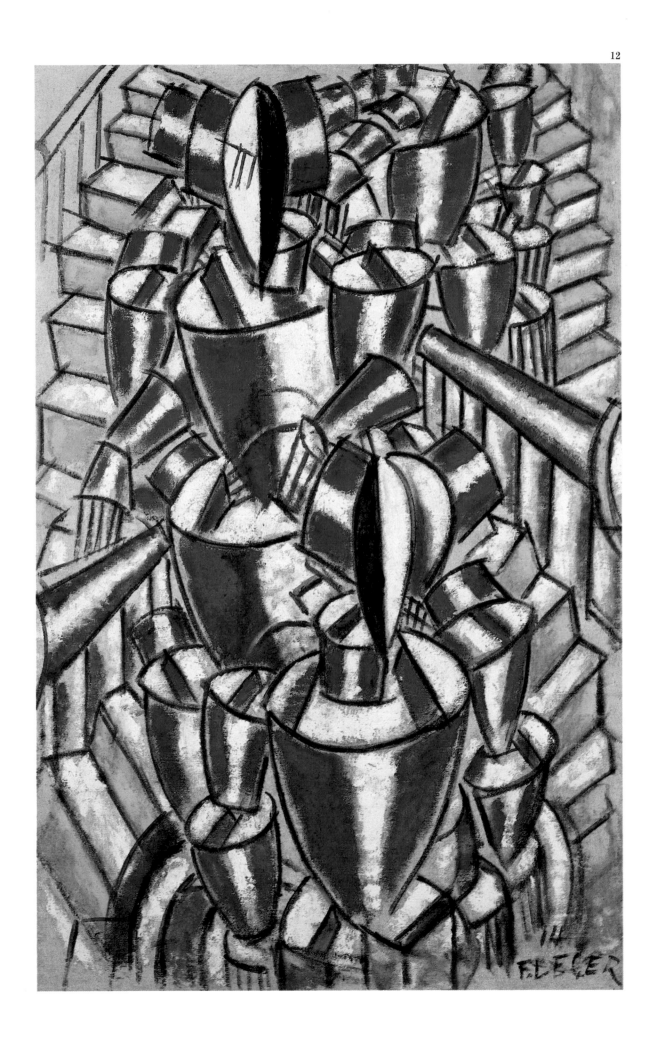

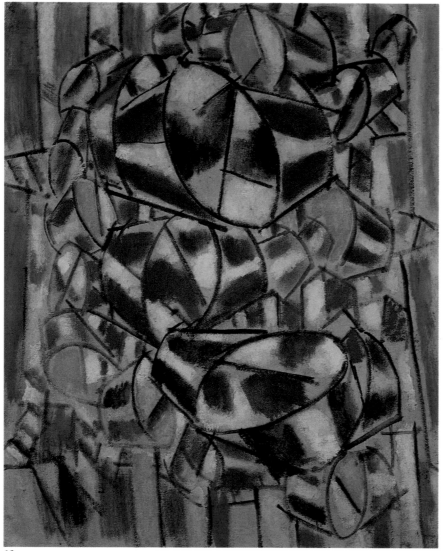

13

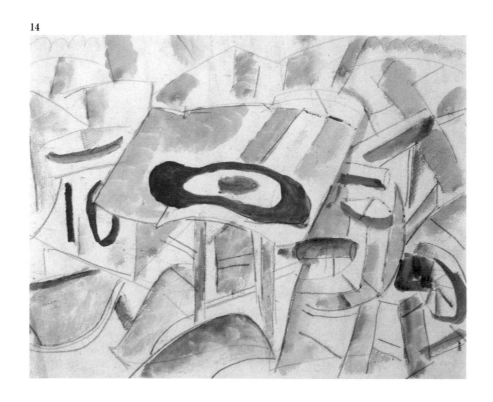

14

13 Contrast of Forms, *1913. The title of this work, also given to other abstract paintings from the same period, explicitly identifies the artist's intentions. Contrast is achieved both through the juxtaposition of straight lines against curves and through the dissonance between colors.*

14 The Insignia (Wrecked Airplane), *1916. The experience of the war gave a new dimension to Léger's work. Here, the forms of the subject have already been "broken up," by combat, and need no further "decomposition" by the artist.*

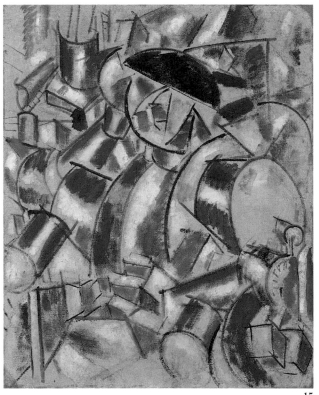

15

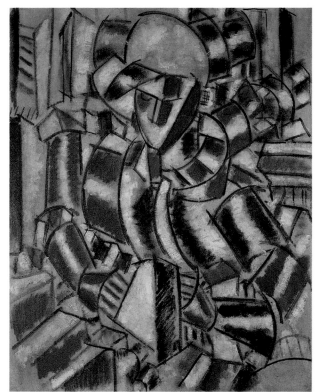

16

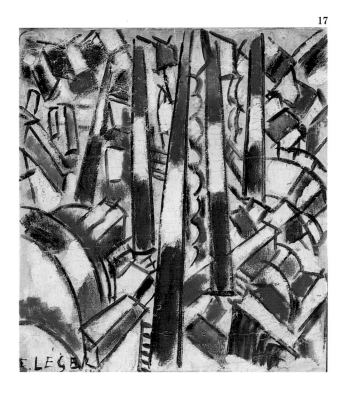

17

15 The Alarm Clock, 1914. *The interaction of contrasting forms here assumes an acoustical quality: the series of concentric curved elements shows the sound vibrations of the alarm clock spreading through the entire picture.*

16 Woman in Red and Green, *1914. As in other works from this period, Léger detaches the figure's contours from its patches of color and leaves some areas of the canvas completely bare.*

17 The Fourteenth of July, *1914. Léger here exploits a motif common in French art since the Impressionists. The principal contrast in this case is between the green texture of the roofs and the red-blue chord of the vertical banners.*

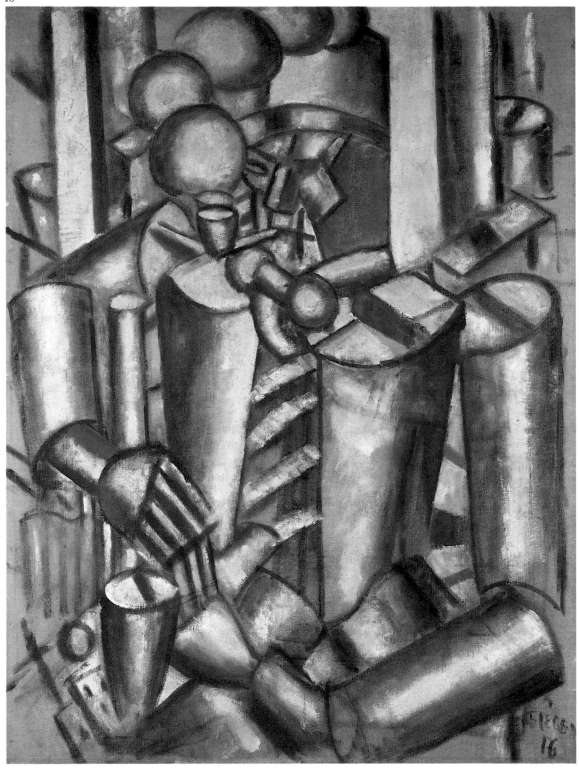

18 Soldier with a Pipe, *1916. This work is another
instance of how the war affected Léger's art,
especially his understanding of the machine
aesthetic. The war also taught him the importance
of "humanizing" the machine, as he did in this
case: the soldier's robotic body is an assemblage of
cylinders and machinelike parts, but at the same
time we cannot help but note the warm red patch on
the soldier's face and the sinuous ascent of the smoke
rising from his pipe.*

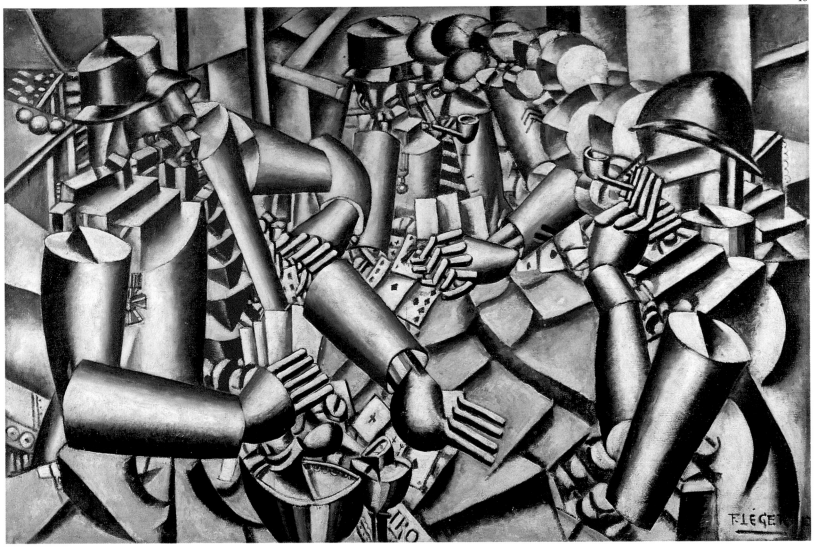

19 The Cardplayers, *1917. This is a synthesis of Léger's experiences in World War I, painted while he convalesced after being gassed at the front. The artist said that "I discovered the dynamism of mechanics through artillery and treaded vehicles…. The breachlock of [a] 75 mm gun opened in the sun taught me more for my artistic evolution than all the museums in the world." In this painting, the figures of the soldiers—of various corps and different ranks, as a homage to military camaraderie—are built from the same cylindrical forms as the shell casings and artillery pieces that had so deeply impressed the painter.*

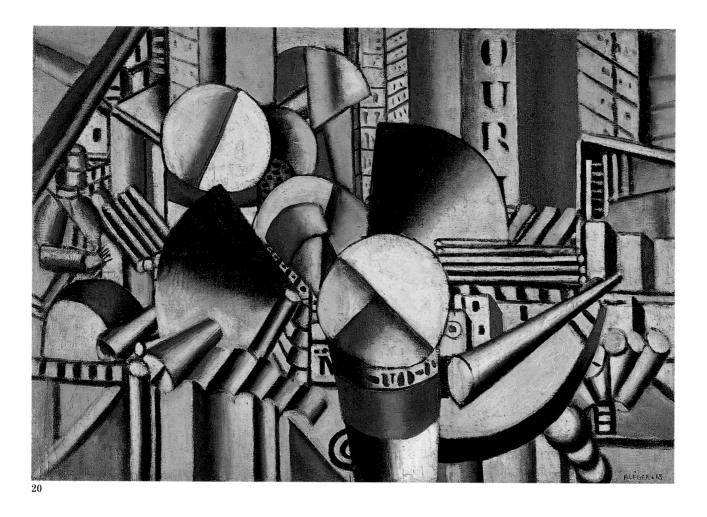

20

The Machine Age

The artists of the early decades of the twentieth century took a number of different stances toward recent mechanical inventions and industrial civilization as a whole—toward what was coming to be known as the Machine Age. First the Dadaists and later the Surrealists, sometimes with violence, sometimes with ironic detachment, exposed its more brutal and absurd aspects, while the Italian Futurists and the Russian Constructivists—from their different ideological positions—defended it as the agent of necessary and beneficial change. Nonetheless, after the terrible casualties of World War I, the first instance of truly mechanized warfare, the accepted view of the Machine Age became generally a negative one—and remained that way, as can be seen from such popular films as Fritz Lang's *Metropolis* (1927) and Charles Chaplin's *Modern Times* (1936).

Léger defended the Machine Age more on artistic than ideological grounds: he was fascinated by the colors and the precisely calibrated shapes of machines, by the metallic sheen of their surfaces. The painter, who understood that modern humanity lives in an environment dominated by mechanical geometry, did not, however, represent machines directly; instead, he extracted from them a number of formal references —shapes, textures, and colors—that enabled him to analyze any motif, whether an industrial object or a nude, in mechanistic terms. That is what he meant when he said: "I have never copied a machine. I invent images of machines, as others paint landscapes from the imagination. The mechanical element is but a means to achieve a sensation of force and power."

20 The Pink Barge, *1918. The interplay between the various overlapping planes— some of them associated with the barge and some with and the city through which it moves—causes the two to merge into a single complex entity. The introduction of stenciled letters accentuates the flatness of the painted surface, pressing the two together.*

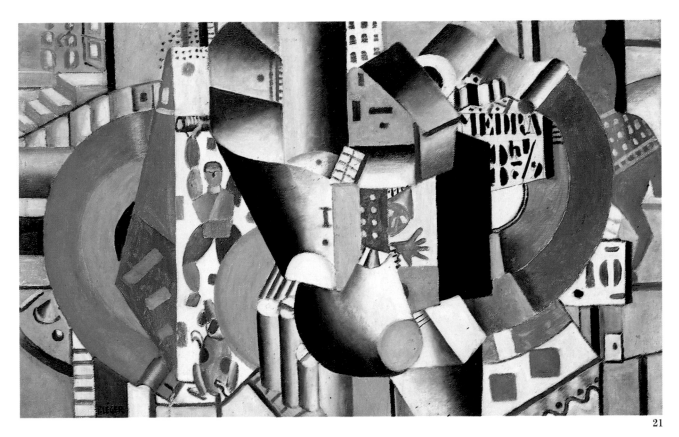

21

21 The Circus, *1918. The circus, a subject offering relatively few opportunities for mechanical treatment, apparently encouraged Léger to preserve the figures' organic character. The weightlifter, the dog, the clown, and the horseback rider (whose silhouette appears at the upper right) are all kept clearly distinct from their geometric setting.*

22 Propellers, *1918. Léger would always remember his visit, accompanied by Marcel Duchamp and Constantin Brancusi, to an international aviation show before World War I. The sight of the polished forms of the airplanes' propellers made a deep impression on the three artists.*

22

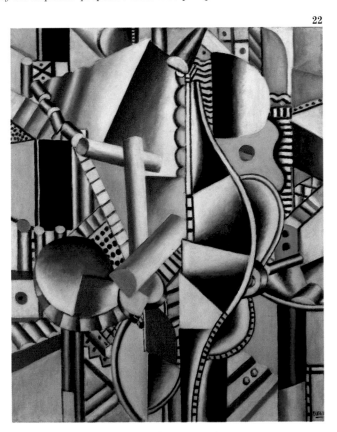

23 The City, *1919. "After the war," Léger said, "walls, streets, objects suddenly became intensely colored. The houses dressed up in blue, yellow, and red. Gigantic letters were written on them. This is radiant, brutal modern life." Above all, it was the assertion of color, the "polychrome invasion," that held his attention: "Color rushes in like a torrent. It swallows up the walls, the streets." And specifically about this painting, he said that "in* The City, *I composed a picture exclusively with pure, flat colors.... Color had become free. It was a reality in its own right. It had a new activity, entirely independent of the objects which, till then, had contained it."*

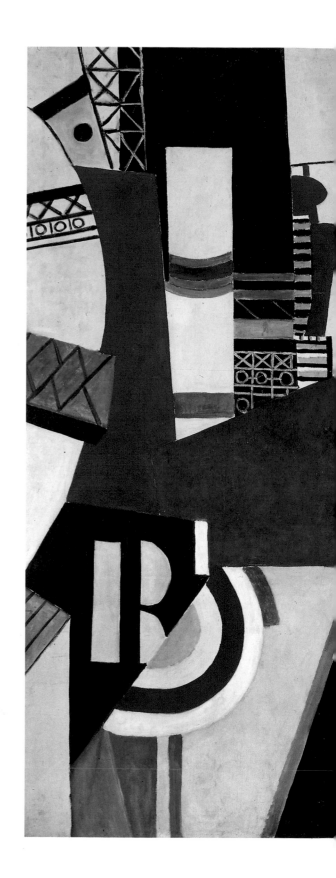

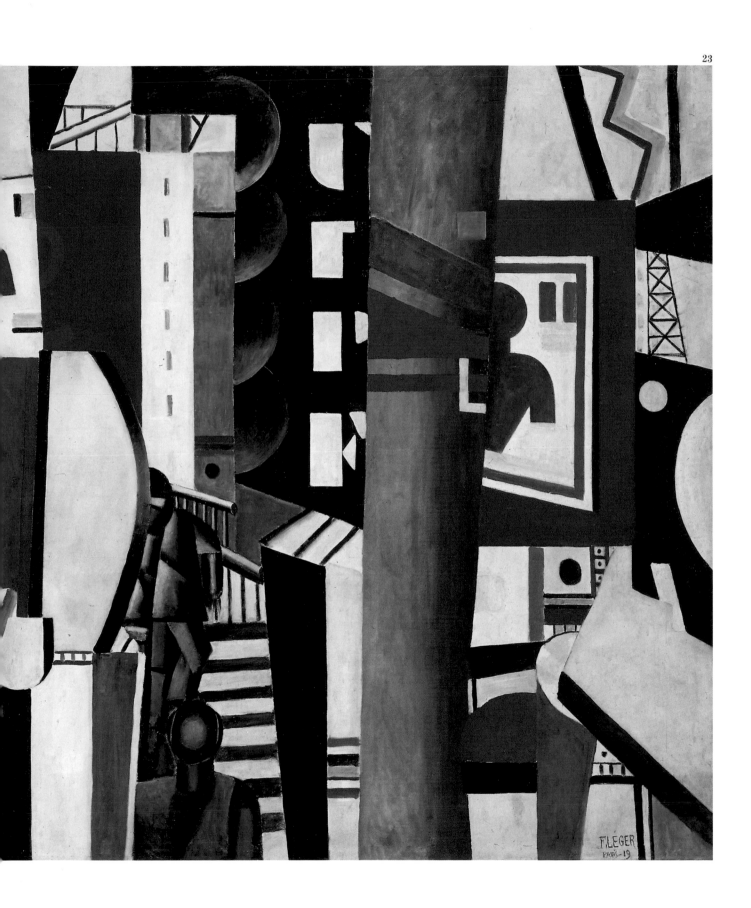

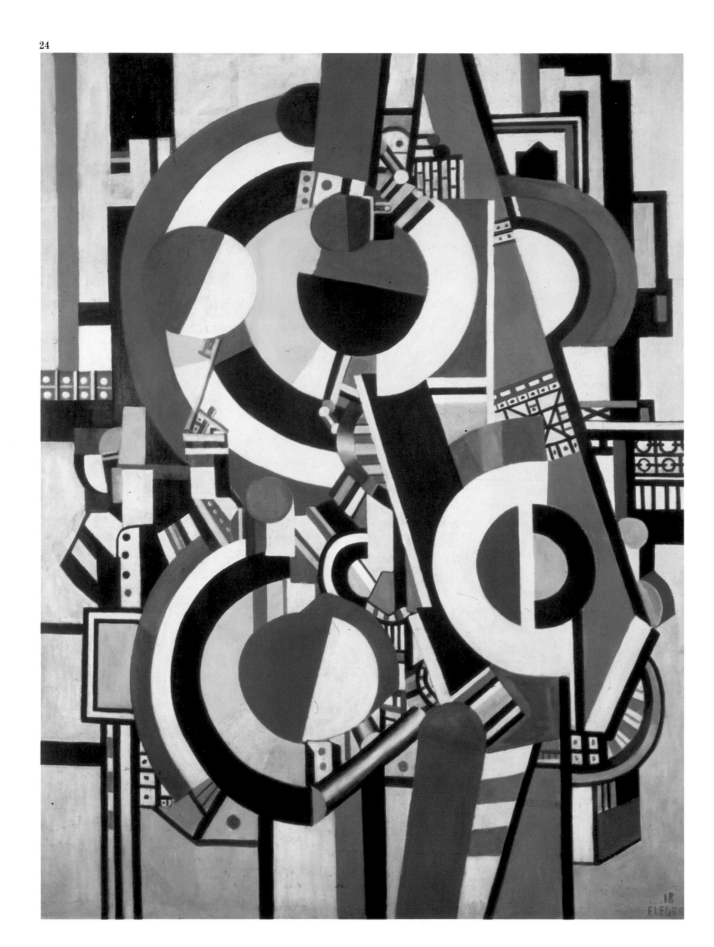

24 The Disks, *1918. As Robert Delaunay did, Léger filled his painting with multicolored disks. But unlike his friend, Léger did not treat them as solar or cosmic forms: his disks are as concrete and as sharply outlined as the gears of a huge machine.*

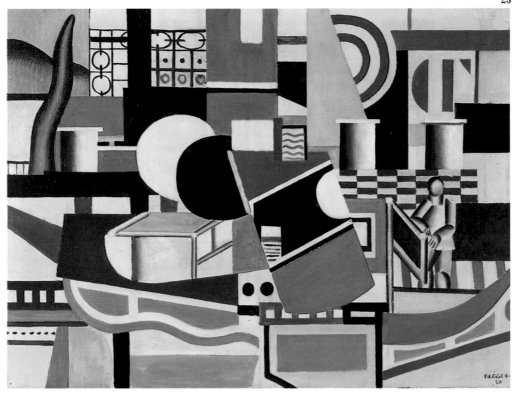

25 The Bridge, *1920. As in other of his Barge paintings, Léger contrasts geometric planes of flat color with rounded forms that have some degree of shading. The geometric shapes here are much more hard-edged than in* The Pink Barge *(plate 20).*

26 Man with a Pipe, *1920. Seemingly among the most anonymous of Léger's figures, the body shown here is one solid mass. Yet the man's head is rather lightheartedly individualized: his hair is neatly combed and there is a puppet's painted smile on his lips.*

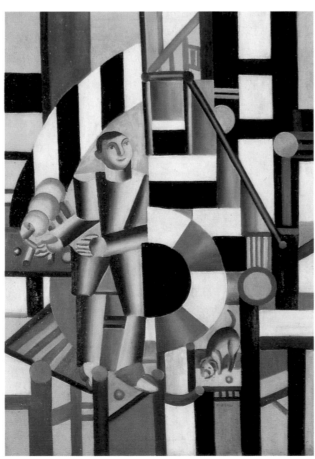

26

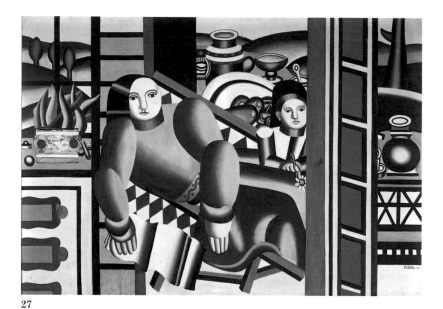

27

27 Mother and Child, *1922. In this painting, inanimate objects—cooking utensils, a flowerpot—are treated as the equals of the two figures. Yet comparing this work with* Woman in Blue *(plate 9) of ten years earlier, it can be seen how far Leger has gone to restore the figure to a central role: instead of flat blue planes that obliquely refer to the woman in that picture, here he painted rounded blue volumes that solidly depict the mother.*

28 Animated Landscape, *1924. The factor that "animates" the landscape may be either the people who figure so prominently in these coldly architectonic surroundings or the band of bright red that enlivens the otherwise subdued color scheme.*

28

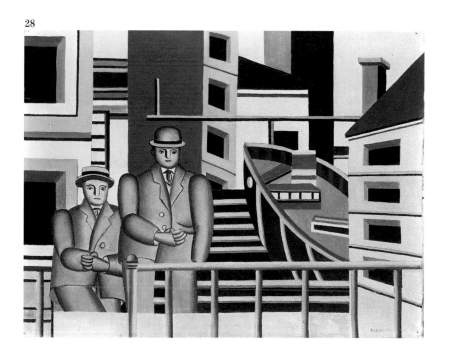

29 Mechanical Elements, *1924. This image is not of a particular machine so much as an imaginary, generalized object. In it, Léger sought to convey the qualities that he felt defined the great mechanical universe: solidity, force, and dynamism.*

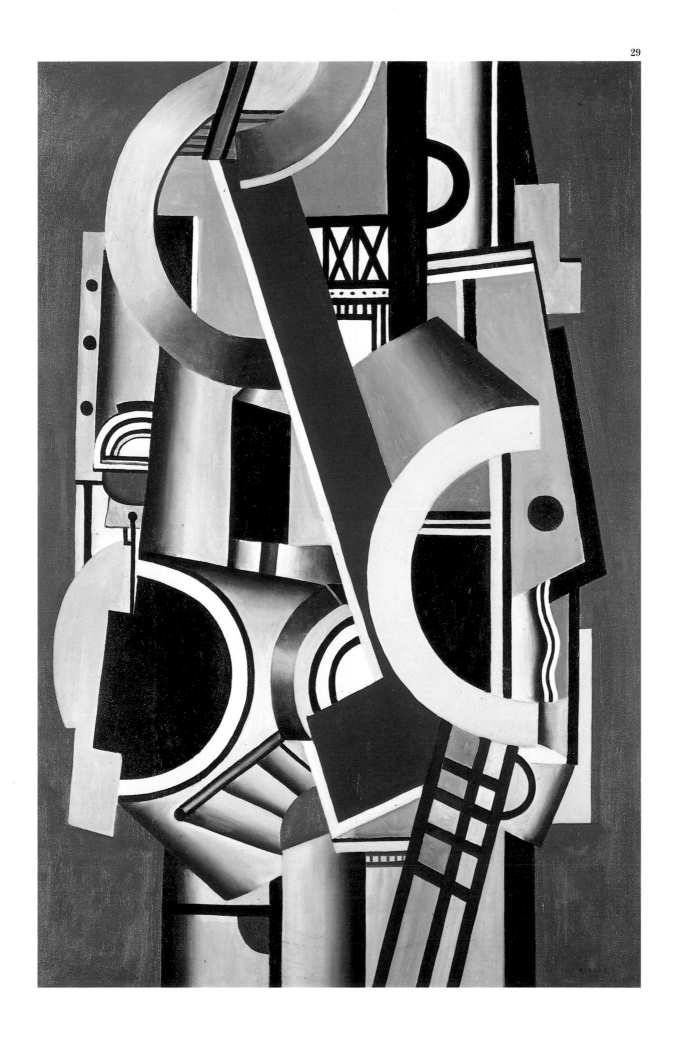

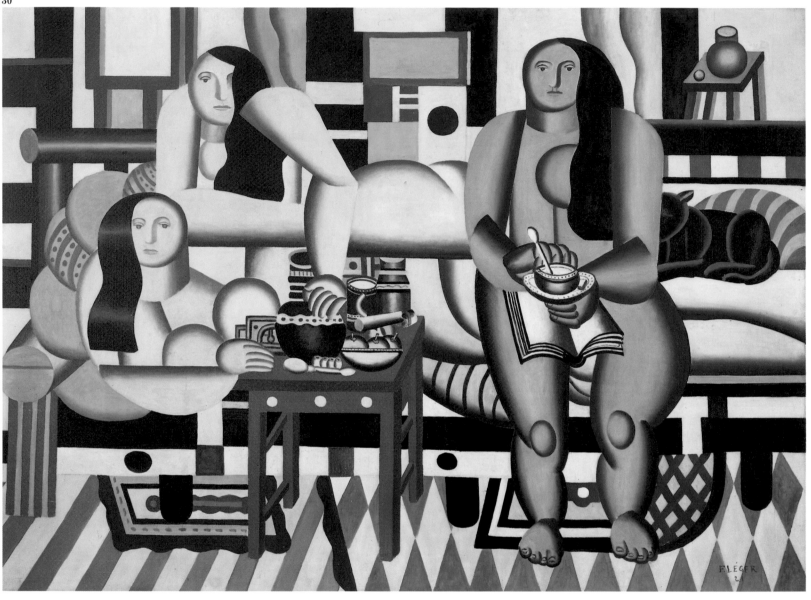

30 Three Women (Le Grand Déjeuner), *1921. Léger once commented about his work that "after the 'mechanical' period came the 'monumental' period, the massive phase, the compositions with large figures.... I had broken down the human body, so I set about putting it together again and rediscovering the human face.... After the dynamism of the 'mechanical' period, I felt a need for large, static figures."*

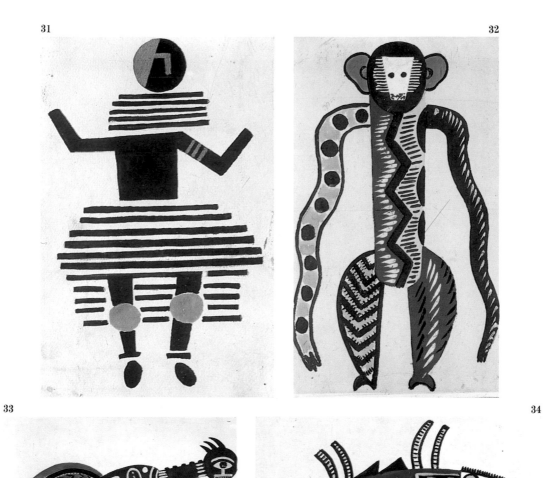

31–34 *Studies for* La Création du monde: Woman's Dress; The
Monkey; Prehistoric Being; The Beetle, *1923. Léger's close friend
the poet Blaise Cendrars conceived a ballet in which the painter,
who designed the costumes and decor, could express his
admiration for African art. The outfits and masks worn by the
dancers are intended to endow the human element with, in the
artist's words, "a visual interest equivalent to that of the props and
sets."*

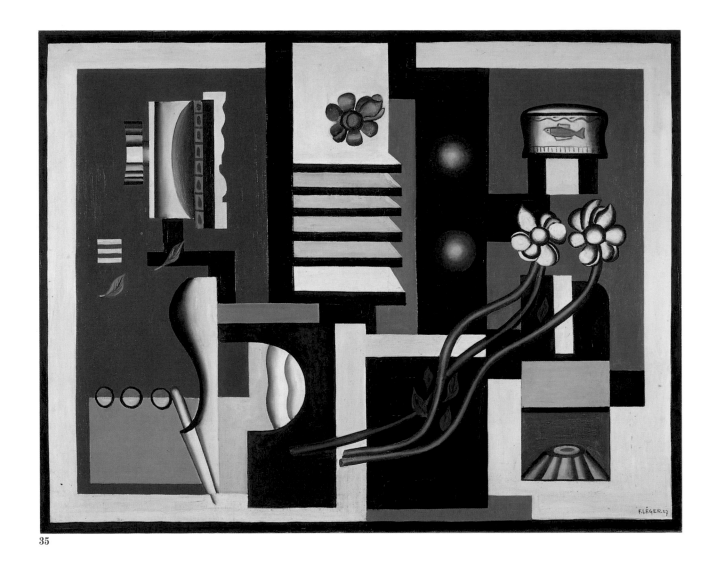

35

Purism

In 1920, Léger met Charles-Édouard Jeanneret, known as Le Corbusier, one of the founding geniuses of modern architecture. The association between the two men was very close. They both shared the idea that painting needed to be integrated into architecture; painting was to be emancipated from the tyranny of the easel and placed in the open spaces offered by the smooth walls of modern buildings. In 1925, on the occasion of the Salon des Arts Décoratifs, that notion led Léger to collaborate with a group of architects in the execution of two large murals, one for the L'Esprit Nouveau pavilion, designed by Le Corbusier, and the other for the French Embassy pavilion, designed by Robert Mallet-Stevens. Le Corbusier's influence on Léger went much deeper than such occasional projects, however. Between 1924 and 1927, the painter's work closely followed the principles of the Purist movement espoused by his architect friend: everyday objects were treated with a degree of formal rigor approaching that of Synthetic Cubism, "purified" of anything superfluous, including the human figure, that might appeal to the personal feelings of the viewer.

35 Still Life, *1927. Léger's resolve to practice an "objective" art materialized in the uniform treatment given to a group of disparate objects, undistracted by their individual associations.*

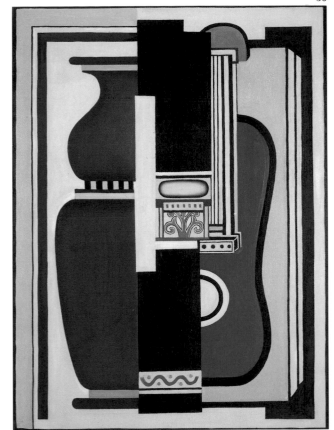

36 Blue Guitar and Vase, *1926. The two items mentioned in the title are separated by a classical decorative fragment. Nonetheless, there are strong contrasts between them: compare the modeled forms of the one with the flat shapes of the other, the warm color of the vase with the guitar's cooler hue, and the way the two objects are framed.*

37 The Accordion, *1926. Like other works from the same period, this painting shows the object in profile, as if it were an architectural cross-section or a schematic diagram. Modeling of forms has almost completely disappeared, while flat planes and pure colors dominate with a geometric rigor that is somewhat reminiscent of Synthetic Cubism.*

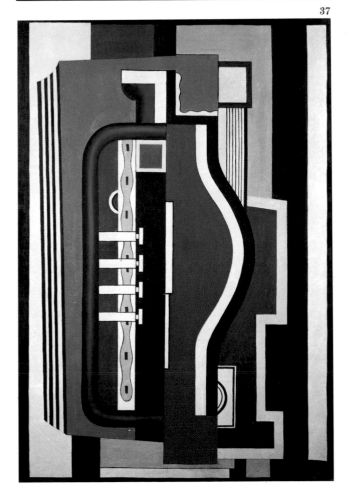

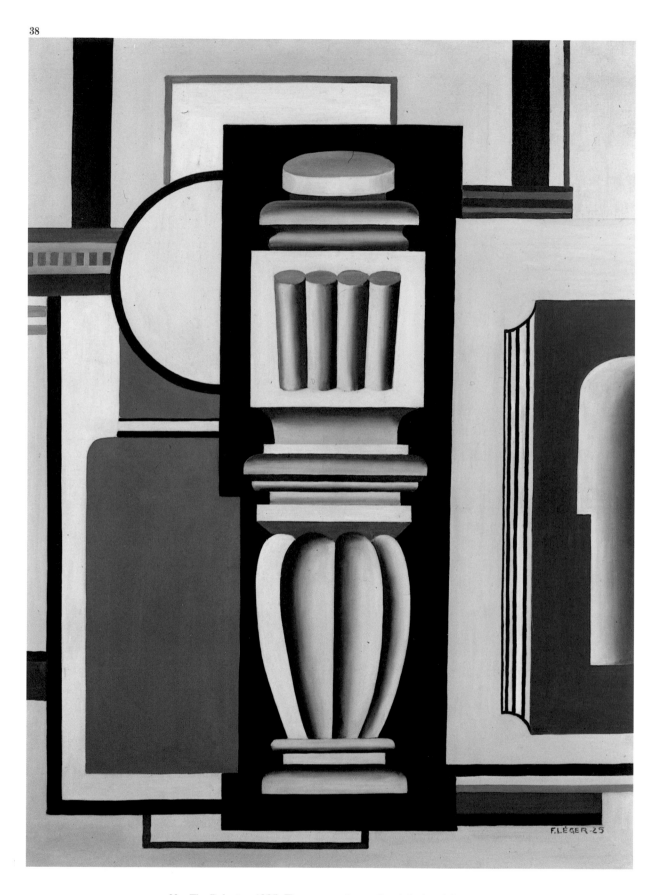

38 The Baluster, *1925. The recurrent use of architectural forms
has led some to call this phase of Léger's work his Doric period.
Here, his focus on an architectural object is heightened by its black
background as well as by the contrast between its rounded volume
and the flatness of its surroundings.*

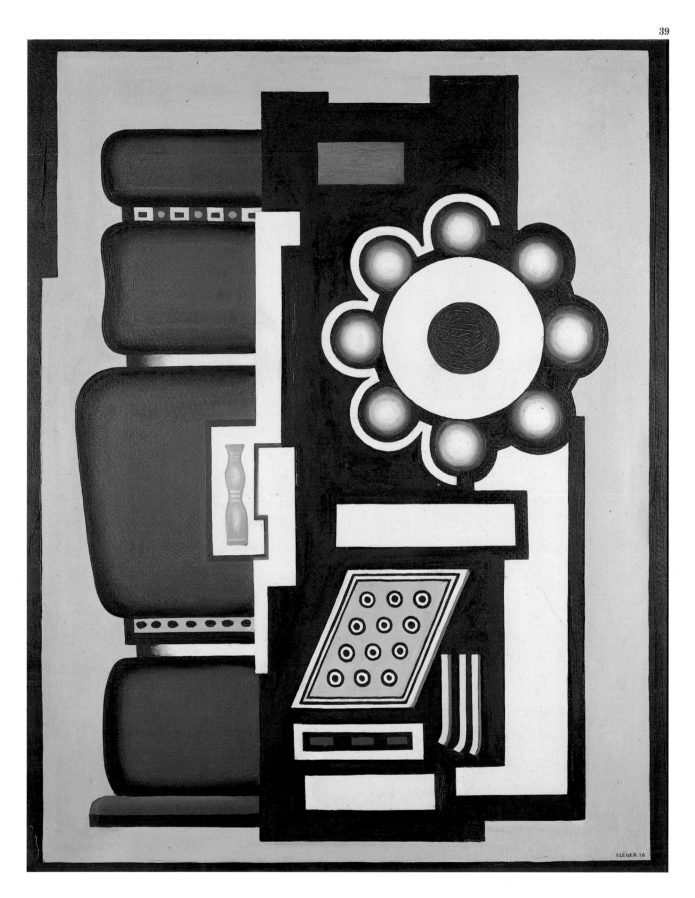

39 Ball Bearing, *1926. In this work, the visual power of smoothly honed mechanical objects leads Léger to dramatize a workaday industrial component. He seeks to honor the ball bearing by framing it in a suitably complex way, placing it amid elaborate technological paraphernalia like a jewel in a rich setting.*

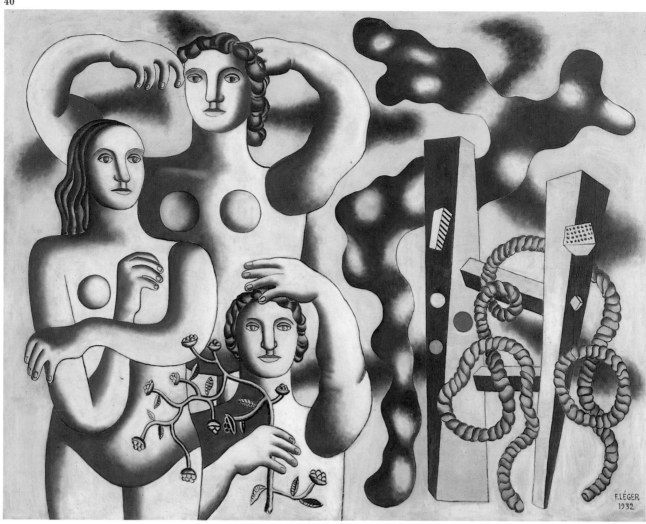

A New Realism

In the late 1920s, Léger's work underwent a profound change. Having grown weary of abstraction (he would later avow that he considered it a wayward preoccupation), at the end of the decade Léger turned again to representational art. The painter now set out to relate the human figure, in visual terms, to the ordinary objects of the day-to-day world. He now began to express his characteristic fondness for contrast by making unusual associations between the figure and everyday things. However, despite a certain superficial similarity, this had little in common with the Surrealists' aim of creating portentous images by juxtaposing disparate realities—the kind of dislocation that the nineteenth-century writer Lautréamont had called "the chance encounter, on an operating table, of an umbrella and a sewing machine." What Léger wanted to demonstrate was an essential democracy and equality among the physical objects in the real world; even the *Mona Lisa* was, as he said, "an object like any other," little different, in terms of its "objecthood," than something as common as a bunch of keys. Nonetheless, despite linking the figure so closely to mundane, impersonal items, Léger did not seek thereby to make the figures themselves look anonymous. His paintings gradually became inhabited by individualized characters; figures, conceived in a very idio-syncratic manner, began to appear in the distinctive poses that would become familiar in his works of the following two decades.

40 Composition with Three Figures, *1932. Throughout his career, Léger gave his own personal interpretation to the principle of contrast. Here, the intense yellow background emphasizes the sculptural sobriety of the black-and-white figures and objects.*

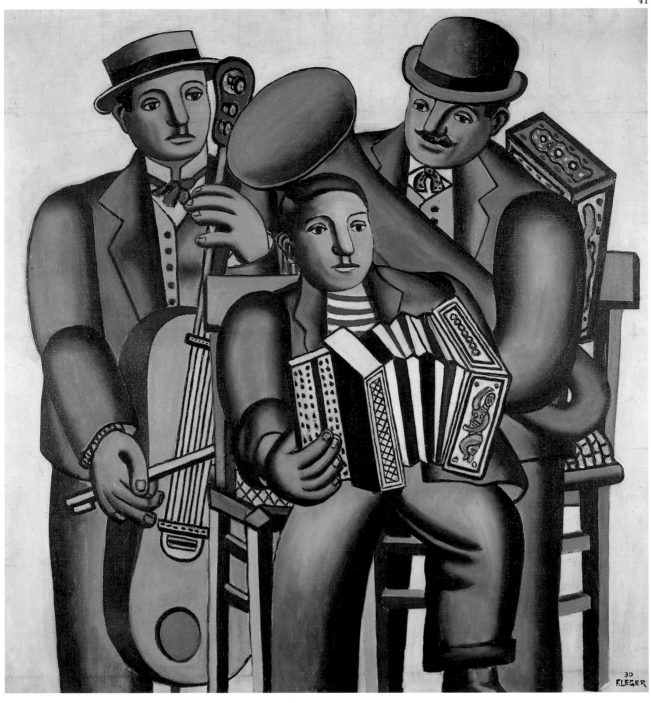

41 Three Musicians, *1930. Léger painted several versions of this composition but never altered the arrangement of the figures. The three musicians are depicted as one compact block and with impassive expressions that belie the festive character of their occupation.*

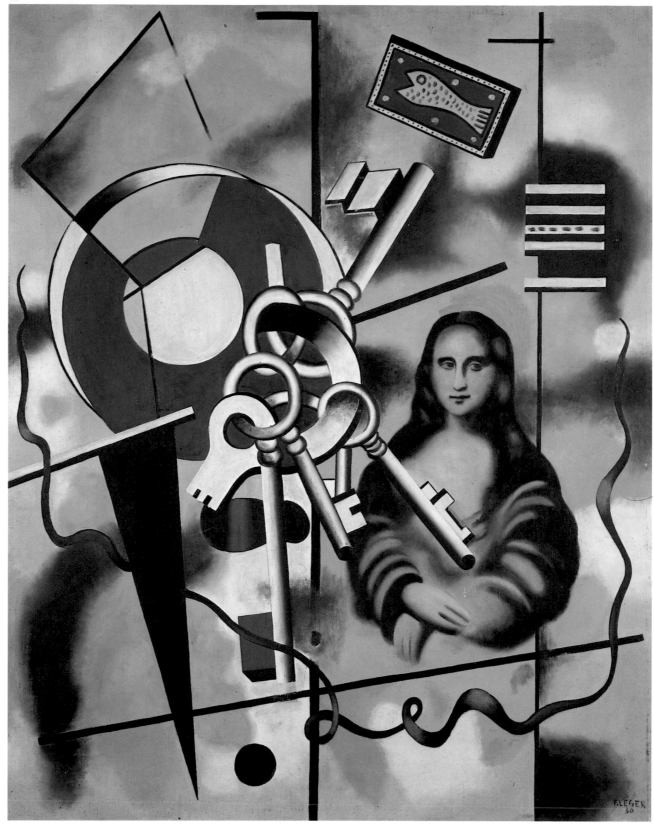

42 "Mona Lisa" with Keys, *1930. The reference to the* Mona Lisa, *a cult object among artworks, had a precedent a decade earlier, when Marcel Duchamp drew a moustache on a reproduction of the painting. Léger, however, had no debunking intention whatsoever. He merely wished to demonstrate that, from a purely visual standpoint, any two objects can be compared, even if one of them is the most famous painting in the history of art.*

43 The Dance, *1929. Anticipating the large compositions of the following decades, these two figures have shed all geometric rigidity, while gaining a more tactile quality. The inclusion of the flower heightens the sense that the dancers are floating in midair.*

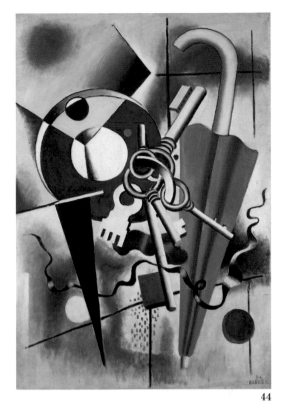

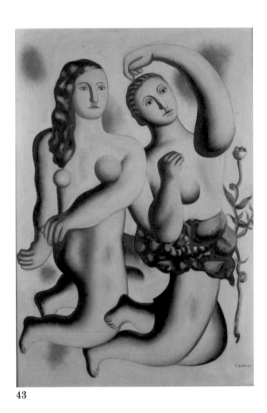

43

44, 45 Composition with Umbrella, *1932;* Contrast of Objects, *1930. Once again a bunch of keys and a disk take center stage in a painting. The changing selection of accompanying objects—Mona Lisa, dancer, umbrella—denies any aesthetic hierarchy among them. As elsewhere in Léger's works, objects are interchangeable.*

45

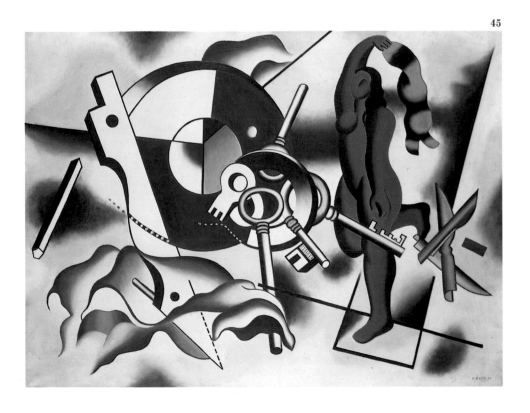

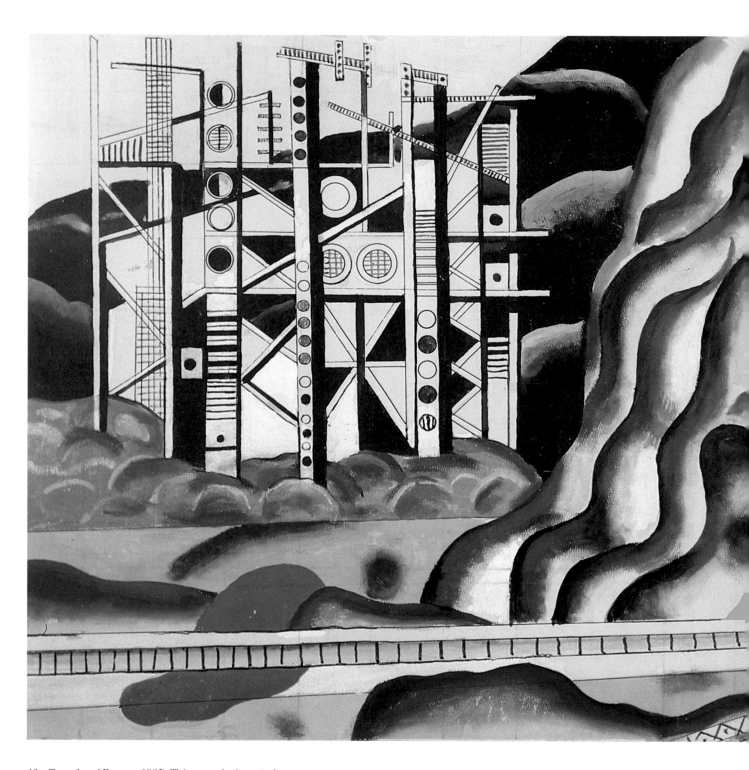

46 Transfer of Forces, *1937. This gouache is a study for a large mural painting that Léger executed for the Palace of Discovery at the Paris World's Fair of 1937. In this virtually abstract composition, the linear precision of the industrial components contrasts with the organic softness of the natural forms.*

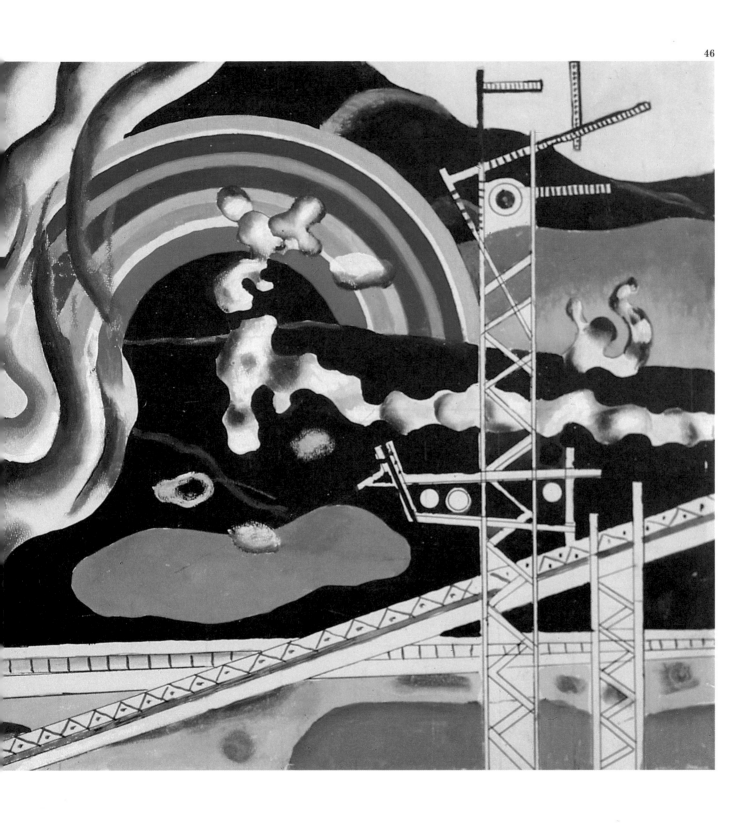

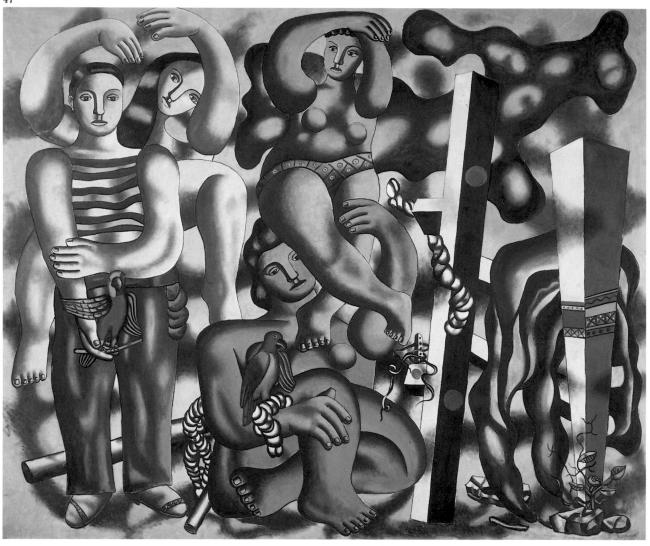

47 Composition with Two Parrots, *1935–39. This huge canvas
anticipates the pictures of acrobats that would become frequent in
Léger's post–World War II production. The artist's characteristically
direct treatment of his subject does not support the interpretation
of those who see in this painting a popular version of the
Judgment of Paris.*

48 Polychrome Flower, *1936. Having freed art from slavish
imitation of the natural motif, the artist can go on to create a
world of his own and invent, as in this case, fantastic flowers with
multicolored petals.*

49 Adam and Eve, *1935–39. In Léger's personal interpretation of
the biblical couple, there is no tragic banishment from Eden. The
first two mortals calmly assume their new, fallen condition. Eve
shows none of the shame at her nakedness told of in the Bible,
while Adam—tattooed and wearing the striped outfit of a sailor or
an acrobat—holds a harmless serpent in check.*

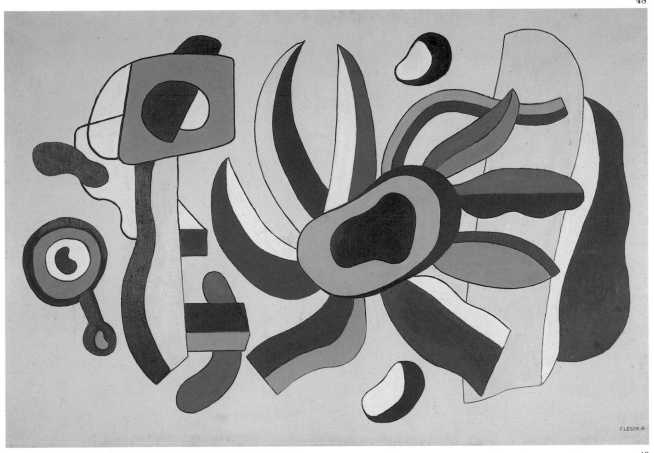

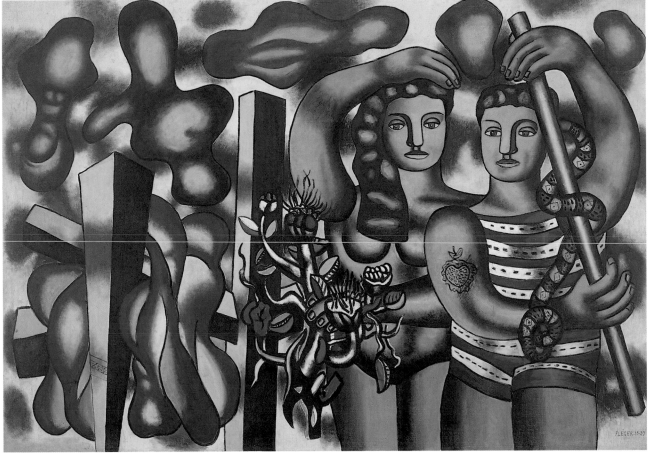

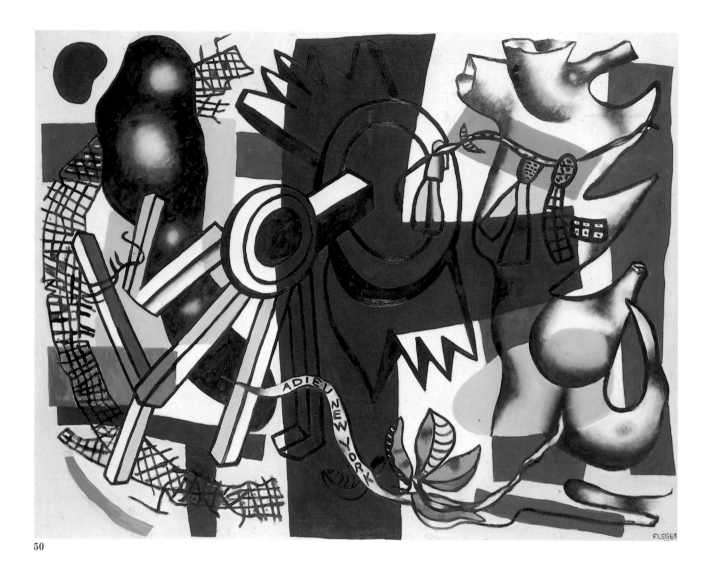

50

America

Léger was eager to explore all aspects of modern life, and he was captivated by the New World, especially by the irresistible energy of New York City, where he arrived in 1940. Nonetheless, the same artist who celebrated the machine was shocked by the sight of industrial dump sites, which seemed to offer veritable metaphors for the wastefulness of modern economies. This experience shaped a series of works in which mechanical components are overrun by lush vegetation. Together with this motif, Léger's American period displays an abundance of intertwined swimmers floating in multicolored waters, a maelstrom that he originally conjured up while looking at the port of Marseilles, waiting to embark for America. The great innovation of this period derives from another specific incident: the revelatory experience of seeing the mottled effects of Broadway's lights and neon signs reflected on the face of an acquaintance with whom he was speaking. This discovery gave rise to a series of paintings in which arbitrary color stripes spread beyond the contours of the figures.

50 Adieu New York, *1946. Léger took leave of the city that had harbored him during the war with this painting, in which color declares its independence from the outlines of objects. As homage to the American experience, the artist depicted the wheel of a pioneer's wagon.*

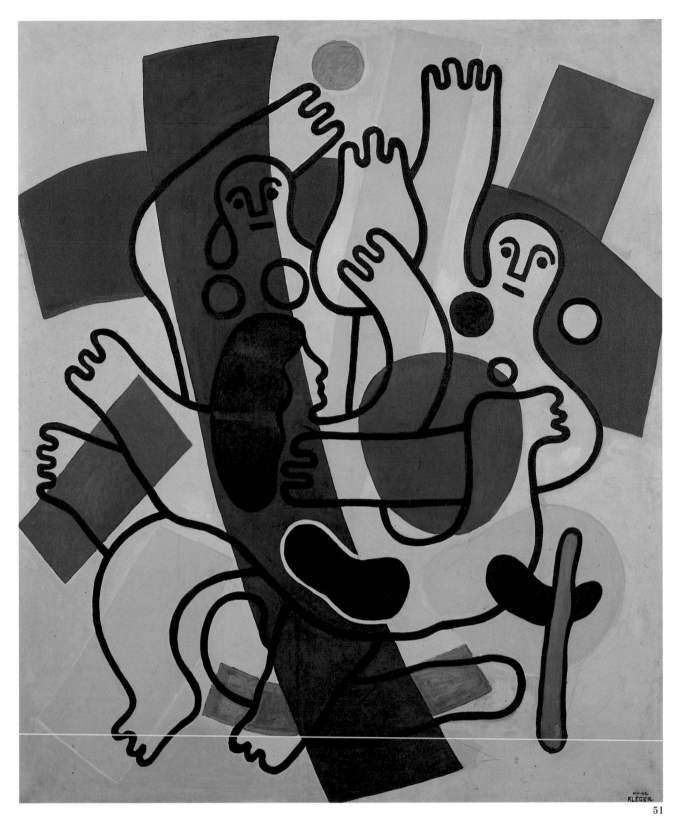

51 The Dance, *1942. This work is imbued
with the energy that Léger admired in
American life. The free use of color bands
heightens the sense of movement of the
three figures, who are not performing a
sedate, formal ballet but a syncopated
modern dance.*

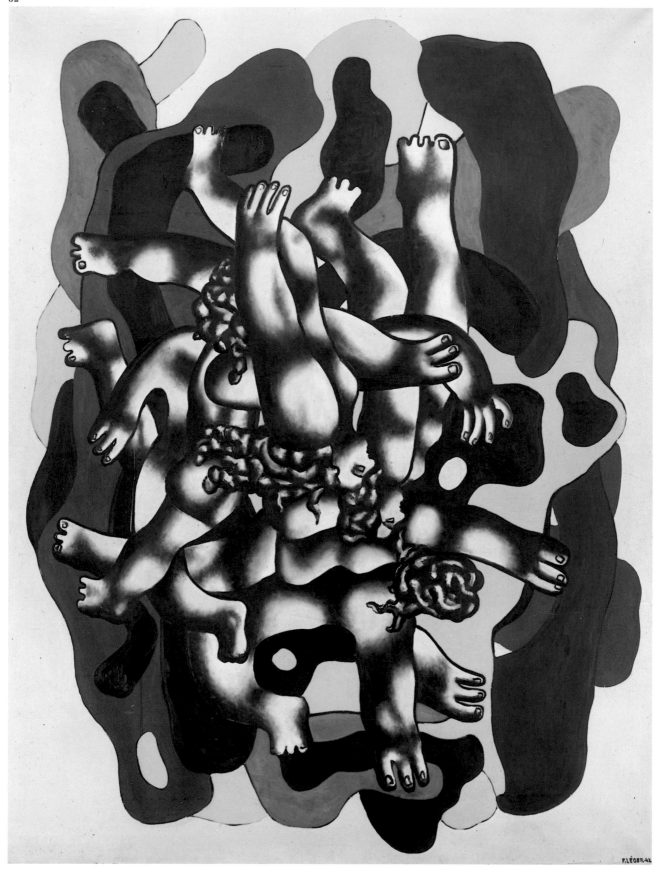

52 The Divers II, *1941–42. With his memory of seeing bathers in Marseilles still vivid, Léger visited a swimming pool in America: "There were not five but two hundred people jumping from the diving board.... Whose head, whose arms were those? You couldn't say. I then painted scattered limbs, and realized that this was much more truthful than Michelangelo's painting every single muscle."*

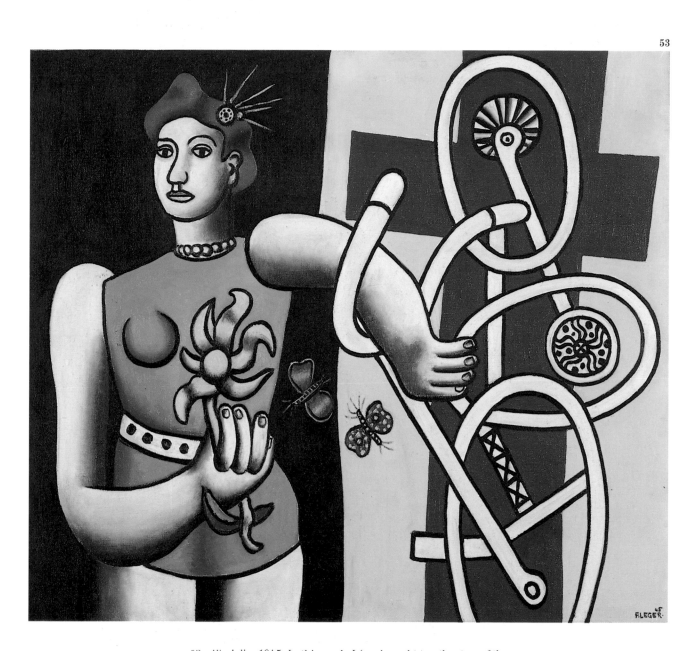

53 Big Julie, *1945. In this work, Léger brought together two of the subjects that would fill his postwar paintings: cyclists and the circus. Both the title and the woman's outfit indicate that she is not an excursionist out for a ride but an acrobat displaying the tools of her trade.*

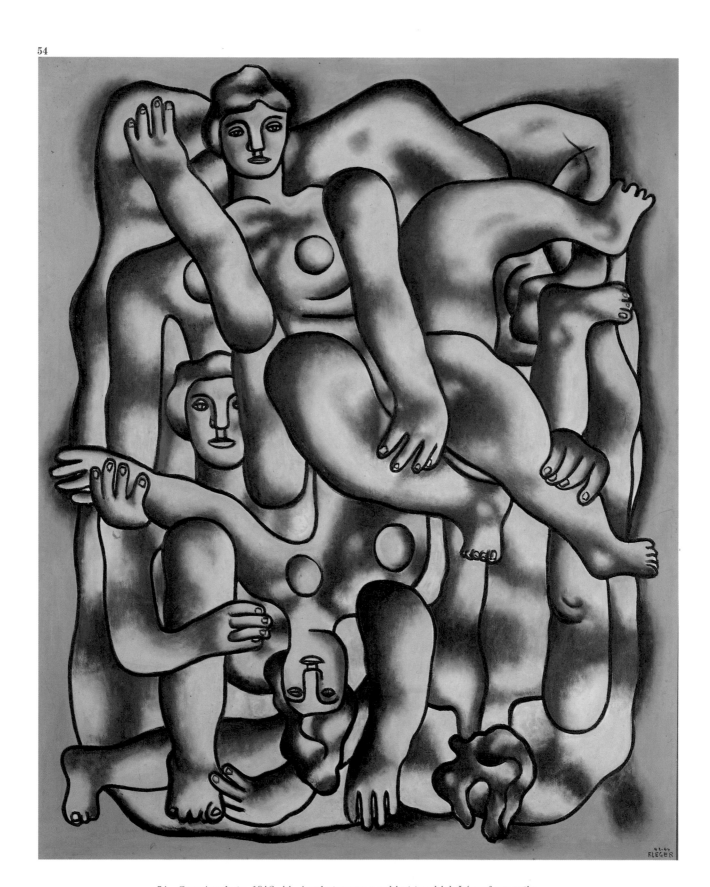

54 Gray Acrobats, *1942–44. Acrobats were a subject to which Léger frequently returned. Here, the athletes' limbs are inextricably intertwined, a compact unit endowed with sculptural solidity, which is emphasized by the modeling of the bodies and the use of monochrome.*

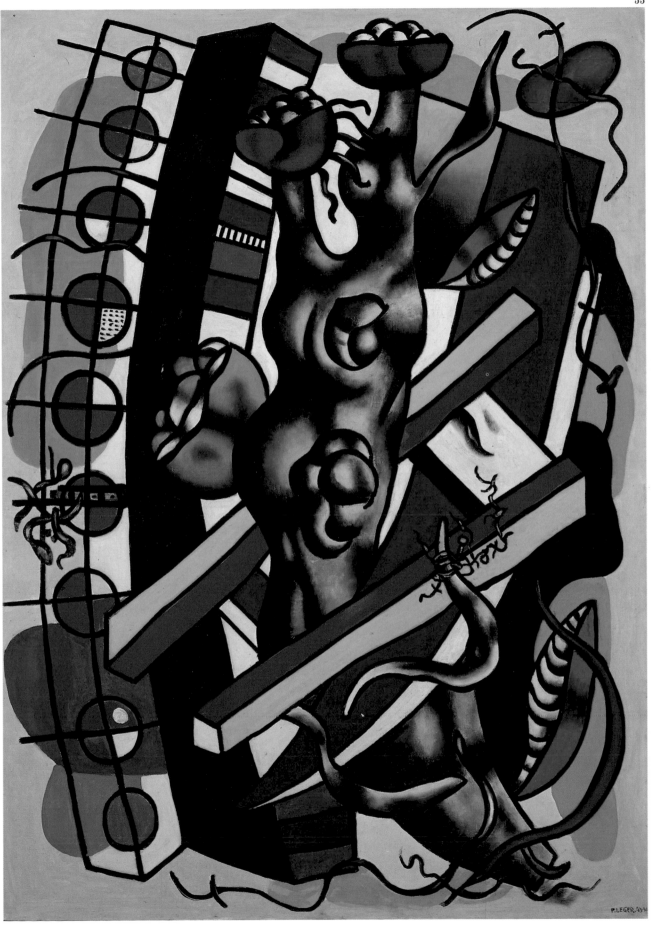

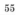

55 The Tree in the Ladder, *1943–44. Repelled yet fascinated by the sight of industrial dumps, Léger devised this twentieth-century version of a "picturesque" ruin. The forces of nature, embodied here by the large tree, are bound eventually to reassert their power over the debris of manmade products.*

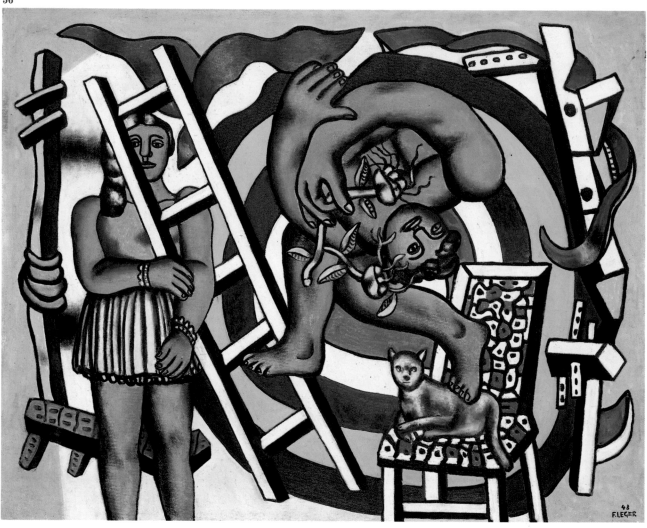

The Joys of Leisure

The American experience reinforced the artist's conviction that there was a need for a more straightforward kind of art, one more easily accepted by ordinary people. Following his return to France after the war, his work came to mirror this view of the social aspect of art and paralleled his political beliefs. For Léger, works of art possessed the potential to transform the context in which daily life is conducted. Their beneficial influence, however, is often blunted, not only by the difficulty of understanding complex art but also by the competing demands of day-to-day living. Léger's disheartening personal experience in the workaday world had already persuaded him that increased leisure time for workers could bring important benefits, and these included fostering the role of the arts in our ordinary existence. If possessed of a more reasonable amount of leisure, he felt, working people would be able to spend time with works of art and thereby improve their very quality of life.

Such utopian notions about the popular benefits of art are consistent with Léger's early admiration for Henri Rousseau, the foremost French master of "naïve" art—painting done without benefit of formal training. Léger's works from this period reverted to such earlier motifs as cyclists or the circus while at the same time extolling the dignity of labor, in settings that speak of the joy of living. They convey a seemingly boundless faith in the continuing possibilities of the modern world.

56 The Acrobat and His Partner, *1948. Léger described the circus world in these terms: "Life is a circuit.... Go to the circus and enter the land of circles in action. Its ring is a huge basin where circular forms develop. Nothing stops; everything is linked together.... A circus is a rotation of volumes, people, animals, and objects. The awkward, dry angle is not at home there."*

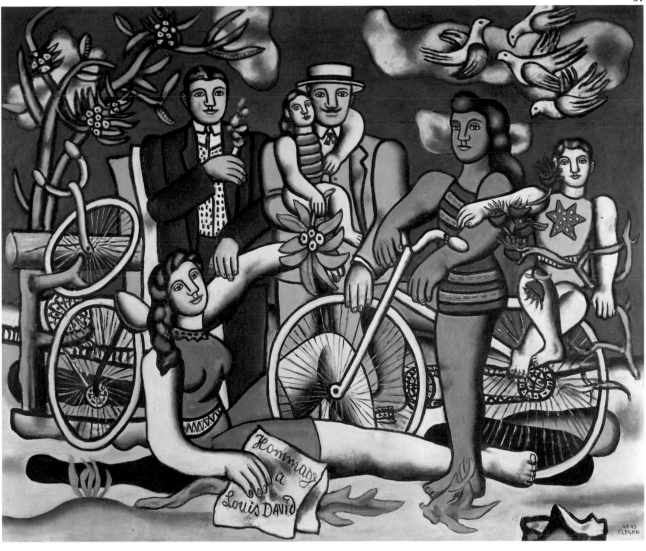

57 Homage to Louis David (Les Loisirs), *1948–49. In this work, the artist wished to mark his return to simplicity, to a more direct kind of art, stripped of abstruse subtleties and comprehensible to all. The inscription held by the recumbent woman refers to the neoclassical painter Jacques-Louis David, whose figures Léger always admired for their sharpness and clarity.*

58

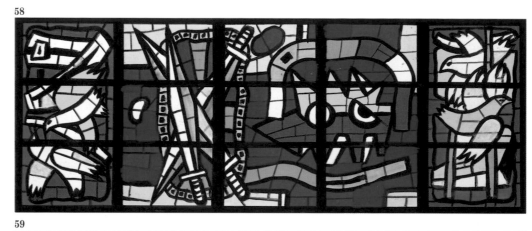

59

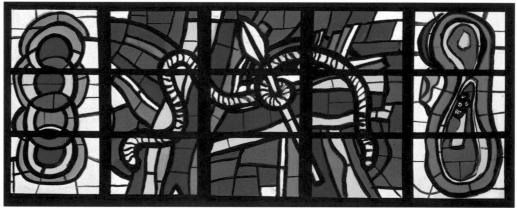

60

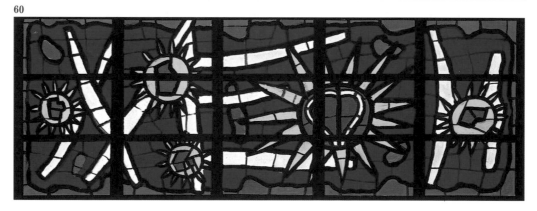

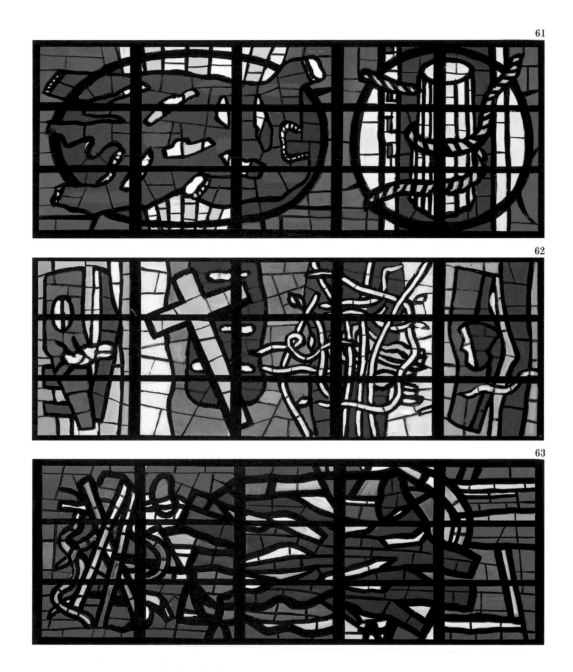

61

62

63

58–63 *Studies for the stained glass windows of the Church of Sacré-Cœur, Audincourt, 1950. Léger always admired the ability of the Catholic Church to affect humankind through artistic means. He met the challenge of decorating a church by using his own idiosyncratic way of depicting objects to represent the traditional Instruments of the Passion.*

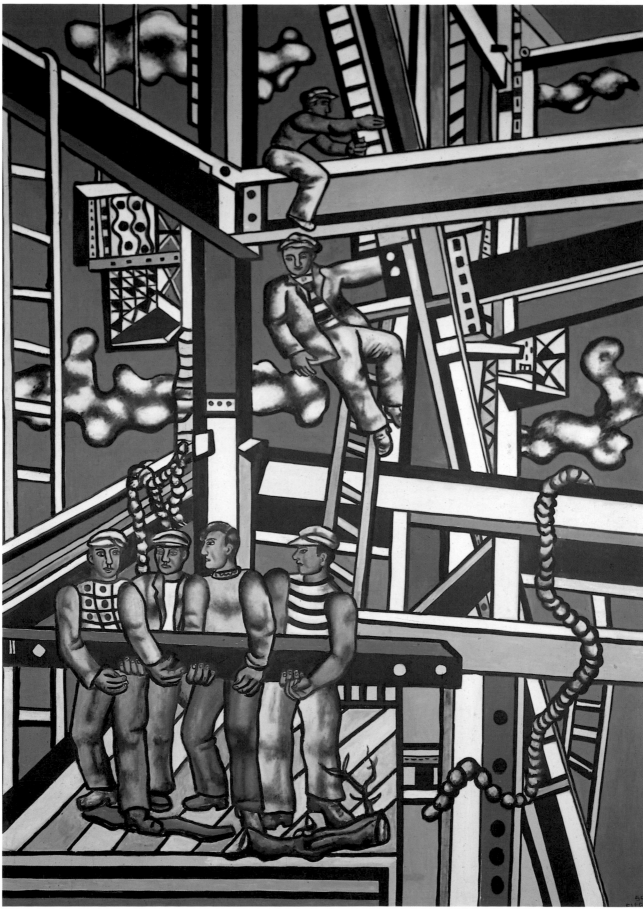

64 The Constructors, *1950. This painting was inspired by the
sight of workmen at a building under construction. Léger
described his objectives this way: "I wanted to render the contrast
between man and his inventions, between the worker and all that
steel architecture.... The clouds, too, form a contrast with the
girders. There is no concession to sentimentality, even if my
figures are more varied and individual."*

65 Three Sisters, *1952. In Léger's last works, the figures acquire a
more solidly physical presence, and their individual characteristics,
now more differentiated, give each a unique personality.*

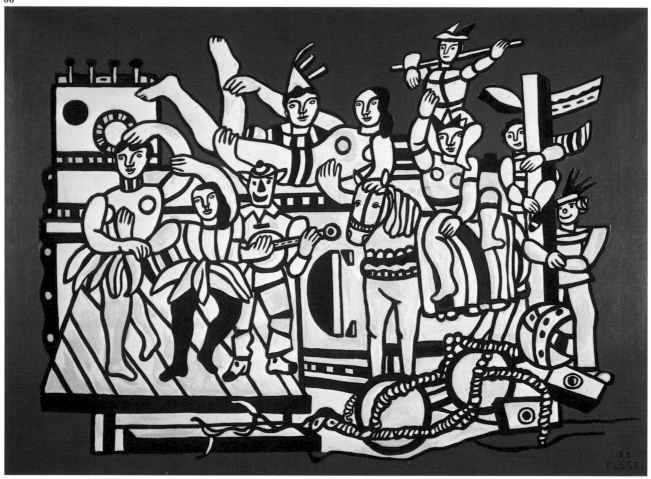

66 The Great Parade with a Red Background, *1953. It took Léger
two years to complete* The Great Parade *(plate 68). The importance
he ascribed to the picture is reflected in the fact that he not only
made countless preliminary drawings—a common practice in
his work—but also developed them into this oil study of fairly
substantial dimensions. Here, the painter relegated color to the
background in order to focus on the black-and-white drawing of
the figures.*

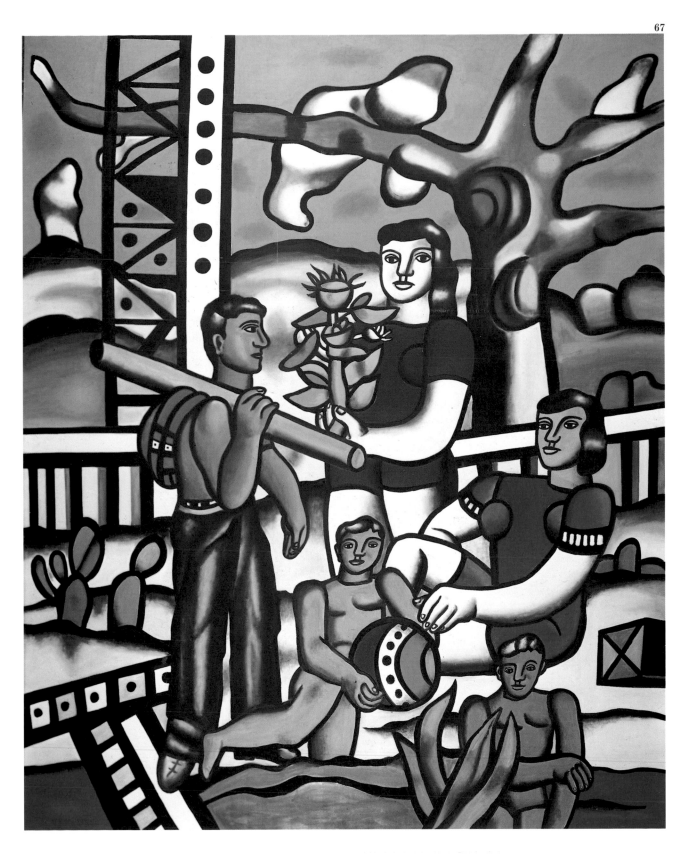

67 The Campers, *1954. The theme of the excursion into the country can boast a glorious tradition in French art: from Édouard Manet and Claude Monet to Georges Seurat and Henri Matisse, nearly all the great painters—albeit with different aesthetic aims—have wanted to capture the holiday feeling of a Sunday outing. With Léger, the introduction of architectonic elements proclaims that the scene remains close to the big city, reminding us that the characters still belong to the working world.*

68 The Great Parade, *1954. In the final version of this work, as very frequently after his sojourn in America, Léger returns to broad planes of color that disregard the outlines of the figures. He lets himself be drawn into the cheerful atmosphere of acrobats who are taking a bow after their performance, and he endows their features with an unprecedented degree of expressiveness.*

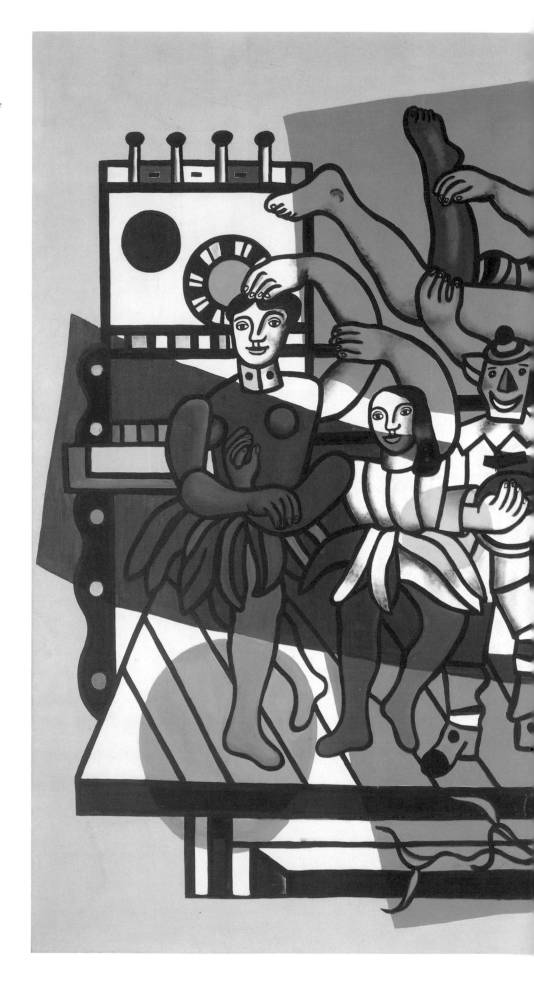

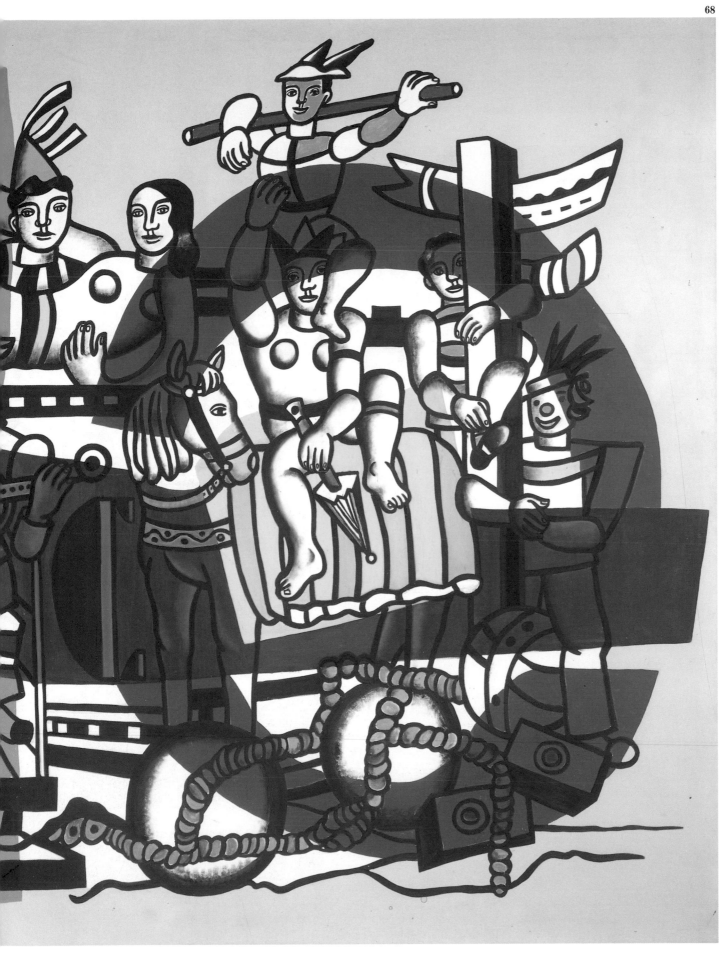

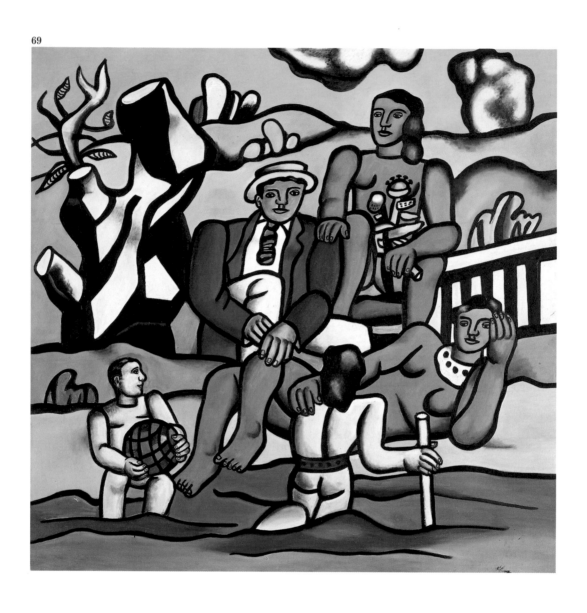

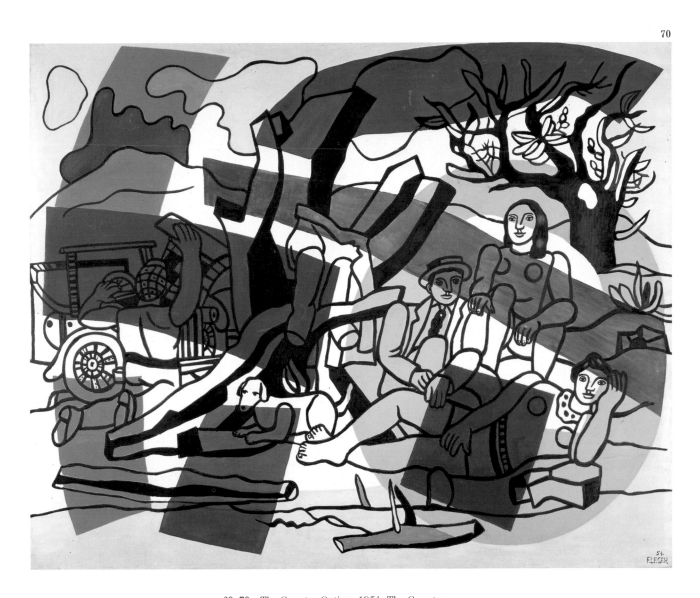

69, 70 The Country Outing, *1954; The Country
Outing, 1954. These two paintings are versions of
essentially the same motif. The tranquility of the first
version (plate 69), where thick black outlines enclose
the color areas, gives way in the second one (plate
70) to an explosion of vital energy, with Léger's
customary large color bands sweeping across the
outlines of the figures.*

List of Plates

1 My Mother's Garden, *1905. Oil on canvas, 18 × 15" (46 × 38 cm). Musée National Fernand Léger, Biot. Gift of Nadia Léger and Georges Bauquier*

2 Portrait of the Artist's Uncle, *1905. Oil on canvas, 17⅜" × 13¾" (44 × 35 cm). Musée National Fernand Léger, Biot. Gift of Nadia Léger and Georges Bauquier*

3 Nudes in the Forest, *1909–10. Oil on canvas, 47¼ × 67" (120 × 170 cm). Rijksmuseum Kröller-Müller, Otterlo*

4 Fruit Dish on a Table, *1909. Oil on canvas, 33 × 38⅞" (83.8 × 98.7 cm). The Minneapolis Institute of Arts. The William Hood Dunwoody Fund*

5 Three Figures (Study for Three Portraits), *1910–11. Oil on canvas, 6'4¾" × 45⅞" (195 × 116.5 cm). Milwaukee Art Museum. Anonymous gift*

6 The Wedding, *1910–11. Oil on canvas, 8'5" × 6'9⅛" (257 × 206 cm). Musée National d'Art Moderne, Centre Georges Pompidou, Paris*

7 The Smokers, *1911. Oil on canvas, 51 × 37⅞" (121.4 × 96.5 cm). Solomon R. Guggenheim Museum, New York. Photo: David Heald*

8 Railroad Crossing, *1912. Oil on canvas, 35⅝ × 31⅞" (93 × 81 cm). Galerie Beyeler, Basel. Photo: Hans Hinz*

9 Woman in Blue, *1912. Oil on canvas, 6'4⅝" × 51" (193 × 130 cm). Kunstmuseum, Basel*

10 Houses Under the Trees (Landscape No. 3), *1914. Oil on canvas, 51 × 38⅛" (130 × 97 cm). Kunstmuseum, Basel. Photo: Hans Hinz*

11 The Staircase, *1913. Oil on canvas, 56¾ × 46½" (144 × 118 cm). Kunsthaus, Zurich*

12 The Staircase, *1914. Oil on canvas, 56¾ × 36¾" (144.5 × 93.5 cm). Moderna Museet, Stockholm*

13 Contrast of Forms, *1913. Oil on canvas, 39⅜ × 31⅞" (100 × 81 cm). Musée National d'Art Moderne, Centre Georges Pompidou. Gift of Jeanne and André Lefèvre*

14 The Insignia (Wrecked Airplane), *1916. Gouache, 9⅝ × 12" (24.5 × 30.5 cm). Musée National Fernand Léger, Biot. Gift of Nadia Léger and Georges Bauquier*

15 The Alarm Clock, *1914. Oil on canvas, 39⅜ × 31⅞" (100 × 81 cm). Musée National d'Art Moderne, Centre Georges Pompidou, Paris. Gift of Jeanne and André Lefèvre*

16 Woman in Red and Green, *1914. Oil on canvas, 39⅜ × 31⅞" (100 × 81 cm). Musée National d'Art Moderne, Centre Georges Pompidou, Paris*

17 The Fourteenth of July, *1914. Oil on canvas, 28⅞ × 23⅝" (73 × 60 cm). Musée National Fernand Léger, Biot. Gift of Nadia Léger and Georges Bauquier*

18 Soldier with a Pipe, *1916. Oil on canvas, 51 × 38⅛" (130 × 97 cm). Kunstsammlung Nordrhein-Westfalen, Düsseldorf*

19 The Cardplayers, *1917. Oil on canvas, 50¾" × 6'4" (129 × 193 cm). Rijksmuseum Kröller-Müller, Otterlo*

20 The Pink Barge, *1918. Oil on canvas, 26⅛ × 36¼" (66.5 × 92 cm). Museum Ludwig, Cologne. Photo: Rheinisches Bildarchiv*

21 The Circus, *1918. Oil on canvas, 22⅞ × 37¼" (58 × 94.5 cm). Musée National d'Art Moderne, Centre Georges Pompidou, Paris*

22 Propellers, *1918. Oil on canvas, 31⅞ × 25¾" (80.9 × 65.4 cm). The Museum of Modern Art, New York. Katherine S. Dreier Bequest*

23 The City, *1919. Oil on canvas, 7'6¾" × 9'11⅛" (236.5 × 305.5 cm). Philadelphia Museum of Art. The A. E. Gallatin Collection*

24 The Disks, *1918. Oil on canvas, 7'10½" × 71" (240 × 190 cm). Musée d'Art Moderne de la Ville de Paris, Paris*

25 The Bridge, *1920. Oil on canvas, 38 × 51⅛" (96.5 × 130 cm). Musée National d'Art Moderne, Centre Georges Pompidou, Paris. Bequest of Eva Gourgaud*

26 Man with a Pipe, *1920. Oil on canvas, 35⅞ × 25⅝" (91 × 65 cm). Musée d'Art Moderne de la Ville de Paris. Gift of the Girardin Collection*

27 Mother and Child, *1922. Oil on canvas, 67¾" × 7'11" (171 × 241.5 cm). Kunstmuseum, Basel. Gift of Raoul La Roche. Photo: Hans Hinz*

28 Animated Landscape, *1924. Oil on canvas, 19⅝ × 23⅝" (50 × 60 cm). Philadelphia Museum of Art. Gift of Bernard Davis*

29 Mechanical Elements, *1924. Oil on canvas, 57½ × 38⅛" (146 × 97 cm). Musée National d'Art Moderne, Centre Georges Pompidou, Paris. Bequest of Eva Gourgaud. Photo: Philippe Migeat*

30 Three Women (Le Grand Déjeuner), *1921. Oil on canvas, 6'¼" × 8'3" (183.5 × 251.5 cm). The Museum of Modern Art, New York. Mrs. Simon Guggenheim Fund*

31 *Study for* La Création du monde: Woman's Dress, *1923. Watercolor, 10⅞ × 6⅝" (27.7 × 17 cm). Dansmuseet, Stockholm*

32 *Study for* La Création du monde: The Monkey, *1923. Watercolor, 11¾ × 6⅝" (30 × 17 cm). Dansmuseet, Stockholm*

33 *Study for* La Création du monde: Prehistoric Being, *1923. Watercolor, 5½ × 11¼" (14 × 28.5 cm). Dansmuseet, Stockholm*

34 *Study for* La Création du monde: The Beetle, *1923. Watercolor, 5⅞ × 9⅞" (15 × 25 cm). Dansmuseet, Stockholm*

35 Still Life, *1927. Oil on canvas, 44⅞ × 57⅞" (114 × 147 cm). Kunstmuseum, Bern. Photo: Gerhard Howald*

36 Blue Guitar and Vase, *1926. Oil on canvas, 51¾ × 38⅜″ (131.5 × 97.5 cm). Kunstmuseum, Basel. Photo: Hans Hinz*

37 The Accordion, *1926. Oil on canvas, 51⅜ × 35″ (130.5 × 89 cm). Stedelijk van Abbemuseum, Eindhoven*

38 The Baluster, *1925. Oil on canvas, 51½ × 38¼″ (129.5 × 97.2 cm). The Museum of Modern Art, New York. Mrs. Simon Guggenheim Fund*

39 Ball Bearing, *1926. Oil on canvas, 57½ × 44⅞″ (146 × 114 cm). Kunstmuseum, Basel. Photo: Hans Hinz*

40 Composition with Three Figures, *1932. Oil on canvas, 50⅜ × 7′6½″ (128 × 230 cm). Musée National d'Art Moderne, Centre Georges Pompidou, Paris*

41 Three Musicians, *1930. Oil on canvas, 46½ × 44⅝″ (118 × 113.5 cm). Von der Heydt-Museum, Wuppertal*

42 "Mona Lisa" with Keys, *1930. Oil on canvas, 35⅞ × 28⅜″ (91 × 72 cm). Musée National Fernand Léger, Biot. Gift of Nadia Léger and Georges Bauquier*

43 The Dance, *1929. Oil on canvas, 51⅛ × 35⅜″ (130 × 90 cm). Musée de Grenoble. Photo: André Morin*

44 Composition with Umbrella, *1932. Oil on canvas, 51⅛ × 35″ (130 × 89 cm). Galerie Louise Leiris, Paris*

45 Contrast of Objects, *1930. Oil on canvas, 38⅛ × 51⅛″ (97 × 130 cm). Musée National d'Art Moderne, Centre Georges Pompidou, Paris*

46 Transfer of Forces, *1937. Gouache, 24⅜ × 39¾″ (62 × 101 cm). Musée National Fernand Léger, Biot. Gift of Nadia Léger and Georges Bauquier*

47 Composition with Two Parrots, *1935–39. Oil on canvas, 13′1½″ × 15′9″ (400 × 480 cm). Musée National d'Art Moderne, Centre Georges Pompidou, Paris*

48 Polychrome Flower, *1936. Oil on canvas, 35 × 51⅛″ (89 × 130 cm). Galerie Louise Leiris, Paris*

49 Adam and Eve, *1935–39. Oil on canvas, 7′5¾″ × 10′7¾″ (228 × 324.5 cm). Kunstsammlung Nordrhein-Westfalen, Düsseldorf*

50 Adieu New York, *1946. Oil on canvas, 51⅛ × 63¾″ (130 × 162 cm). Musée National d'Art Moderne, Centre Georges Pompidou, Paris*

51 The Dance, *1942. Oil on canvas, 72 × 60¾″ (183 × 154 cm). Galerie Louise Leiris, Paris*

52 The Divers II, *1941–42. Oil on canvas, 7′6″ × 68″ (228.6 × 172.8 cm). The Museum of Modern Art, New York. Mrs. Simon Guggenheim Fund*

53 Big Julie, *1945. Oil on canvas, 44 × 50⅛″ (111.8 × 127.3 cm). The Museum of Modern Art, New York. Acquired through the Lillie P. Bliss Bequest*

54 Gray Acrobats, *1942–44. Oil on canvas, 72 × 57⅞″ (183 × 147 cm). Musée National d'Art Moderne, Centre Georges Pompidou, Paris*

55 The Tree in the Ladder, *1943–44. Oil on canvas, 71⅝ × 49¼″ (182 × 125 cm). Galerie Louise Leiris, Paris*

56 The Acrobat and His Partner, *1948. Oil on canvas, 51 × 63¾″ (130 × 162 cm). Tate Gallery, London*

57 Homage to Louis David (Les Loisirs), *1948–49. Oil on canvas, 60⅝″ × 6′1″ (154 × 185 cm). Musée National d'Art Moderne, Centre Georges Pompidou, Paris*

58–63 *Studies for the stained glass windows of the Church of Sacré-Cœur, Audincourt, 1950. Six gouaches: 14½ × 36⅞″ (37 × 93.5 cm); 14½ × 35¾″ (37 × 91 cm); 14½ × 37″ (37 × 94 cm); 13⅜ × 38½″ (34 × 98 cm); 13⅜ × 38⅛″ (34 × 97 cm); 14½ × 37″ (37 × 94 cm). Musée National d'Art Moderne, Centre Georges Pompidou, Paris. Photo: Jacqueline Hyde*

64 The Constructors, *1950. Oil on canvas, 9′10″ × 6′6¾″ (300 × 200 cm). Musée National Fernand Léger, Biot. Gift of Nadia Léger and Georges Bauquier*

65 Three Sisters, *1952. Oil on canvas, 63¾ × 51⅛″ (162 × 130 cm). Staatsgalerie, Stuttgart*

66 The Great Parade with a Red Background, *1953. Oil on canvas, 44⅞ × 61″ (114 × 155 cm). Musée National Fernand Léger, Biot. Gift of Nadia Léger and Georges Bauquier*

67 The Campers, *1954. Oil on canvas, 9′10″ × 8′½″ (300 × 245 cm). Musée National Fernand Léger, Biot. Gift of Nadia Léger and Georges Bauquier*

68 The Great Parade, *1954. Oil on canvas, 9′9¾″ × 13′1½″ (299 × 400 cm). Solomon R. Guggenheim Museum, New York. Photo: David Heald*

69 The Country Outing, *1954. Oil on canvas, 6′4½″ × 6′4½″ (194.5 × 194.5 cm). Museum Ludwig, Cologne. Photo: Rheinisches Bildarchiv*

70 The Country Outing, *1954. Oil on canvas, 8′½″ × 9′10½″ (245 × 301 cm). Fondation Maeght, Saint-Paul-de-Vence. Gift of M. and A. Maeght, 1964. Photo: Claude Germain*

Selected Bibliography

Bauquier, Georges. *Léger.* Paris: Maeght, 1987.

Descargues, Pierre. *Fernand Léger.* Paris: Cercle d'Art, 1955.

Green, Christopher. *Léger and the Avant-Garde.* New Haven, Conn., and London: Yale University Press, 1976.

Léger, Fernand. *Functions of Painting.* Translated by Alexandra Anderson, edited and with an introduction by Edward F. Fry, preface by George L. K. Morris. New York: Viking, 1973.

———. *Le Cirque.* Biot: Musée National Fernand Léger, n.d.

Schmalenbach, Werner. *Fernand Léger.* Paris: Cercle d'Art, 1991.

Zervos, Christian. *Fernand Léger: Oeuvres de 1905 à 1952.* Paris: Cahiers d'Art, 1952.

Series Coordinator, English-language edition: Ellen Rosefsky Cohen
Editor, English-language edition: James Leggio
Designer, English-language edition: Judith Michael

Library of Congress Catalog Card Number: 95–78425
ISBN 0–8109–4688–2

Printed and bound in Spain by La Polígrafa, S.L.
Parets del Vallès (Barcelona)
Dep. Leg.:B.43.754-1995